PICADOR MODERN
CLASSICS

Considered one of the greatest critics of her generation, Susan Sontag followed up her monumental On Photography *with an extended study of human violence, reflecting on a question first posed by Virginia Woolf in* Three Guineas: *How in your opinion are we to prevent war?*

One of the distinguishing features of modern life is that it supplies countless opportunities for regarding (at a distance, through the medium of photography) horrors taking place throughout the world. But are viewers inured—or incited—to violence by the depiction of cruelty? Is the viewer's perception of reality eroded by the daily barrage of such images? What does it mean to care about the sufferings of others far away?

First published more than twenty years after her now classic book *On Photography,*

which changed how we understand the very condition of being modern, *Regarding the Pain of Others* challenges our thinking not only about the uses and means of images, but about how war itself is waged (and understood) in our time, the limits of sympathy, and the obligations of conscience.

PUBLISHER'S NOTE

For more than twenty years, Picador has been producing beautifully packaged literary fiction and nonfiction books from Manhattan's Flatiron building. Our Modern Classics line pairs iconic books with a design that's both small enough to fit in your pocket and unique enough to stand out on your bookshelf.

ABOUT THE AUTHOR

SUSAN SONTAG (1933–2004) was the author of four novels, *The Benefactor*, *Death Kit*, *The Volcano Lover*, and *In America*, which won the 2000 National Book Award for Fiction; a collection of stories, *I, etcetera*; several plays, including *Alice in Bed* and *Lady from the Sea*; and seven works of nonfiction, among them *On Photography*, which won the National Book Critics Circle Award for criticism, *Illness as Metaphor*, and *Where the Stress Falls*. Her books have been translated into thirty-two languages. In 2001, she was awarded the Jerusalem Prize for the body of her work; in 2003, she received the Prince of Asturias Prize for Literature and the Peace Prize of the German Book Trade.

PRAISE FOR SUSAN SONTAG'S
REGARDING THE PAIN OF OTHERS

"I suspect Susan Sontag has written a book others thought of writing but chickened out of. . . . Timely as it is, Sontag's extended meditation on the imagery of war in *Regarding the Pain of Others* is guaranteed to make some readers uneasy. . . . Sontag is a moralist, as anyone who thinks about violence against the innocent is liable to become. The time she spent in Sarajevo under fire gives her the authority. . . . If photography is a form of knowledge, writing about it with critical discernment and passion, as she does, is bound to make trouble for every variety of intellectual and moral smugness."

—Charles Simic, *The New York Review of Books*

"Susan Sontag's *On Photography* was published in 1977. It became, almost instantly, a bible. . . . Its readers are not just the university young . . . [but also] the men and

women at the sharp end—those you find edging up bullet-scarred streets with Nikons dangling around their flak jackets have read Sontag, too. They ask themselves constantly why they are doing the work they do, and to whom they are doing it, and whether anyone cares whether they do it or not. If any one person provided the words for that self-questioning, it was Susan Sontag. She wrote that book when the images of Vietnam were still fresh. Now, as the photographers line up for accreditation to yet another war she has returned to the subject. . . . We cannot yet know which images are going to freeze-frame [the Iraq] conflict in popular memory, but this wise and somber book warns that some older styles of antiwar photography may be powerless this time."

—Neal Ascherson, *Los Angeles Times Book Review*

"As the images come out of Iraq, Sontag's plainspoken, self-questioning book furnishes meditation of a high order. . . . Her oscillating and humbled mindfulness re-

stores photography to its place in the humanist tradition. . . . [Sontag] has honored beauty and justness, and she has chronicled how they were almost extinguished in the most devastatingly genocidal century to date. Without her, the dead Iraqi child on al-Jazeera would be just one of many, a signpost pointing toward the twin nihilisms of inevitability and ignorance."
 —Lorraine Adams, *The Washington Post*

"*Regarding the Pain of Others* is not simply a repetition of the earlier writings on photography; rather, it is a genuine return to the source of the energy driving Sontag's critical prose from the 1960s and '70s. . . . A longtime reader of Sontag notices that her discussion of Matthew Brady's images of the Civil War—or photojournalistic coverage of downtown New York, autumn 2001—land her in the middle of familiar questions about the history of sensibility in a culture shaped by the mechanical reproduction of imagery. . . . *Regarding the Pain of Others* invites, and rewards, more than one reading." —Scott McLemee, *Newsday*

REGARDING THE
PAIN OF OTHERS

REGARDING THE
PAIN OF OTHERS

SUSAN SONTAG

PICADOR MODERN CLASSICS

Farrar, Straus and Giroux
New York

picadorusa.com • picadorbookroom.tumblr.com
twitter.com/picadorusa • facebook.com/picadorusa

Picador® is a U.S. registered trademark and is used by Macmillan Publishing Group, LLC, under license from Pan Books Limited.

For book club information, please visit facebook.com/picadorbookclub or email marketing @picadorusa.com.

Designed by Steven Seighman

The Library of Congress has cataloged the Farrar, Straus and Giroux edition as follows:

Sontag, Susan, 1933–
 Regarding the pain of others / Susan Sontag.
 p. cm.
 ISBN 978-0-374-24858-1 (hardcover)
 1. War and society. 2. War photography—Social aspects.
3. War in art—Social aspects. 4. Photojournalism—Social aspects.
5. Atrocities. 6. Violence. I. Title.
 HM554.S65 2003
 303.6—dc21 2002192527

Picador Modern Classics ISBN 978-1-250-16068-3

Our books may be purchased in bulk for promotional, educational, or business use. Please contact your local bookseller or the Macmillan Corporate and Premium Sales Department at 1-800-221-7945, extension 5442, or by email at MacmillanSpecialMarkets@macmillan.com.

First published by Farrar, Straus and Giroux

First Picador Edition: February 2004

First Picador Modern Classics Edition: November 2017

10 9 8 7 6 5 4 3 2 1

For David

. . . aux vaincus!

　　　　　　　　—Baudelaire

The dirty nurse, Experience . . .

　　　　　　　　—Tennyson

REGARDING THE
PAIN OF OTHERS

1

IN JUNE 1938 Virginia Woolf published *Three Guineas*, her brave, unwelcomed reflections on the roots of war. Written during the preceding two years, while she and most of her intimates and fellow writers were rapt by the advancing fascist insurrection in Spain, the book was couched as the very tardy reply to a letter from an eminent lawyer in London who had asked, "How in your opinion are we to prevent war?" Woolf begins by observing tartly that a truthful dialogue between them may not be possible. For though they belong to the same class, "the educated class," a vast gulf separates them: the lawyer is a man and she is a woman. Men make war. Men (most men) like war, since for men there is "some glory, some necessity, some satisfaction in fighting" that women (most women) do not feel or enjoy. What does an educated—read: privileged, well-off—woman like her know

of war? Can her recoil from its allure be like his?

Let us test this "difficulty of communication," Woolf proposes, by looking together at images of war. The images are some of the photographs the beleaguered Spanish government has been sending out twice a week; she footnotes: "Written in the winter of 1936–37." Let's see, Woolf writes, "whether when we look at the same photographs we feel the same things." She continues:

> This morning's collection contains the photograph of what might be a man's body, or a woman's; it is so mutilated that it might, on the other hand, be the body of a pig. But those certainly are dead children, and that undoubtedly is the section of a house. A bomb has torn open the side; there is still a bird-cage hanging in what was presumably the sitting room . . .

The quickest, driest way to convey the inner commotion caused by these photo-

graphs is by noting that one can't always make out the subject, so thorough is the ruin of flesh and stone they depict. And from there Woolf speeds to her conclusion. We do have the same responses, "however different the education, the traditions behind us," she says to the lawyer. Her evidence: both "we"—here women are the "we"—and you might well respond in the same words.

> You, Sir, call them "horror and disgust." We also call them horror and disgust . . . War, you say, is an abomination; a barbarity; war must be stopped at whatever cost. And we echo your words. War is an abomination; a barbarity; war must be stopped.

Who believes today that war can be abolished? No one, not even pacifists. We hope only (so far in vain) to stop genocide and to bring to justice those who commit gross violations of the laws of war (for there are laws of war, to which combatants should be held), and to be able to stop specific wars by

imposing negotiated alternatives to armed conflict. It may be hard to credit the desperate resolve produced by the aftershock of the First World War, when the realization of the ruin Europe had brought on itself took hold. Condemning war as such did not seem so futile or irrelevant in the wake of the paper fantasies of the Kellogg-Briand Pact of 1928, in which fifteen leading nations, including the United States, France, Great Britain, Germany, Italy, and Japan, solemnly renounced war as an instrument of national policy; even Freud and Einstein were drawn into the debate with a public exchange of letters in 1932 titled "Why War?" Woolf's *Three Guineas*, appearing toward the close of nearly two decades of plangent denunciations of war, offered the originality (which made this the least well received of all her books) of focusing on what was regarded as too obvious or inapposite to be mentioned, much less brooded over: that war is a man's game—that the killing machine has a gender, and it is male. Nevertheless, the temerity of Woolf's version of "Why War?" does not make her

revulsion against war any less conventional in its rhetoric, in its summations, rich in repeated phrases. And photographs of the victims of war are themselves a species of rhetoric. They reiterate. They simplify. They agitate. They create the illusion of consensus.

Invoking this hypothetical shared experience ("we are seeing with you the same dead bodies, the same ruined houses"), Woolf professes to believe that the shock of such pictures cannot fail to unite people of good will. Does it? To be sure, Woolf and the unnamed addressee of this book-length letter are not any two people. Although they are separated by the age-old affinities of feeling and practice of their respective sexes, as Woolf has reminded him, the lawyer is hardly a standard-issue bellicose male. His antiwar opinions are no more in doubt than are hers. After all, his question was not, What are *your* thoughts about preventing war? It was, How in your opinion are *we* to prevent war?

It is this "we" that Woolf challenges at the start of her book: she refuses to allow

her interlocutor to take a "we" for granted.
But into this "we," after the pages devoted
to the feminist point, she then subsides.

No "we" should be taken for granted
when the subject is looking at other people's
pain.

Who are the "we" at whom such shock-
pictures are aimed? That "we" would in-
clude not just the sympathizers of a smallish
nation or a stateless people fighting for its
life, but—a far larger constituency—those
only nominally concerned about some nasty
war taking place in another country. The
photographs are a means of making "real"
(or "more real") matters that the privileged
and the merely safe might prefer to ignore.

"Here then on the table before us are
photographs," Woolf writes of the thought
experiment she is proposing to the reader
as well as to the spectral lawyer, who is
eminent enough, as she mentions, to have
K.C., King's Counsel, after his name—and

may or may not be a real person. Imagine then a spread of loose photographs extracted from an envelope that arrived in the morning post. They show the mangled bodies of adults and children. They show how war evacuates, shatters, breaks apart, levels the built world. "A bomb has torn open the side," Woolf writes of the house in one of the pictures. To be sure, a cityscape is not made of flesh. Still, sheared-off buildings are almost as eloquent as bodies in the street. (Kabul, Sarajevo, East Mostar, Grozny, sixteen acres of lower Manhattan after September 11, 2001, the refugee camp in Jenin . . .) Look, the photographs say, *this* is what it's like. This is what war *does*. And *that*, that is what it does, too. War tears, rends. War rips open, eviscerates. War scorches. War dismembers. War *ruins*.

Not to be pained by these pictures, not to recoil from them, not to strive to abolish what causes this havoc, this carnage—these, for Woolf, would be the reactions of a moral monster. And, she is saying, we are not monsters, we members of the educated

class. Our failure is one of imagination, of empathy: we have failed to hold this reality in mind.

But is it true that these photographs, documenting the slaughter of noncombatants rather than the clash of armies, could only stimulate the repudiation of war? Surely they could also foster greater militancy on behalf of the Republic. Isn't this what they were meant to do? The agreement between Woolf and the lawyer seems entirely presumptive, with the grisly photographs confirming an opinion already held in common. Had the question been, How can we best contribute to the defense of the Spanish Republic against the forces of militarist and clerical fascism?, the photographs might instead have reinforced their belief in the justness of that struggle.

The pictures Woolf has conjured up do not in fact show what war, war as such, does. They show a particular way of waging war, a way at that time routinely described as "barbaric," in which civilians are the target. General Franco was using the same tactics of bombardment, massacre, torture, and the

killing and mutilation of prisoners that he had perfected as a commanding officer in Morocco in the 1920s. Then, more acceptably to ruling powers, his victims had been Spain's colonial subjects, darker-hued and infidels to boot; now his victims were compatriots. To read in the pictures, as Woolf does, only what confirms a general abhorrence of war is to stand back from an engagement with Spain as a country with a history. It is to dismiss politics.

For Woolf, as for many antiwar polemicists, war is generic, and the images she describes are of anonymous, generic victims. The pictures sent out by the government in Madrid seem, improbably, not to have been labeled. (Or perhaps Woolf is simply assuming that a photograph should speak for itself.) But the case against war does not rely on information about who and when and where; the arbitrariness of the relentless slaughter is evidence enough. To those who are sure that right is on one side, oppression and injustice on the other, and that the fighting must go on, what matters is precisely who is killed and by whom. To an Israeli

Jew, a photograph of a child torn apart in the attack on the Sbarro pizzeria in downtown Jerusalem is first of all a photograph of a Jewish child killed by a Palestinian suicide bomber. To a Palestinian, a photograph of a child torn apart by a tank round in Gaza is first of all a photograph of a Palestinian child killed by Israeli ordnance. To the militant, identity is everything. And all photographs wait to be explained or falsified by their captions. During the fighting between Serbs and Croats at the beginning of the recent Balkan wars, the same photographs of children killed in the shelling of a village were passed around at both Serb and Croat propaganda briefings. Alter the caption, and the children's deaths could be used and reused.

Images of dead civilians and smashed houses may serve to quicken hatred of the foe, as did the hourly reruns by Al Jazeera, the Arab satellite television network based in Qatar, of the destruction in the Jenin refugee camp in April 2002. Incendiary as that footage was to the many who watch Al Jazeera throughout the world, it did not tell

them anything about the Israeli army they were not already primed to believe. In contrast, images offering evidence that contradicts cherished pieties are invariably dismissed as having been staged for the camera. To photographic corroboration of the atrocities committed by one's own side, the standard response is that the pictures are a fabrication, that no such atrocity ever took place, those were bodies the other side had brought in trucks from the city morgue and placed about the street, or that, yes, it happened and it was the other side who did it, to themselves. Thus the chief of propaganda for Franco's Nationalist rebellion maintained that it was the Basques who had destroyed their own ancient town and former capital, Guernica, on April 26, 1937, by placing dynamite in the sewers (in a later version, by dropping bombs manufactured in Basque territory) in order to inspire indignation abroad and reinforce the Republican resistance. And thus a majority of Serbs living in Serbia or abroad maintained right to the end of the Serb siege of Sarajevo, and even after, that the Bosnians

themselves perpetrated the horrific "bread-line massacre" in May 1992 and "market massacre" in February 1994, lobbing large-caliber shells into the center of their capital or planting mines in order to create some exceptionally gruesome sights for the foreign journalists' cameras and rally more international support for the Bosnian side.

Photographs of mutilated bodies certainly can be used the way Woolf does, to vivify the condemnation of war, and may bring home, for a spell, a portion of its reality to those who have no experience of war at all. However, someone who accepts that in the world as currently divided war can become inevitable, and even just, might reply that the photographs supply no evidence, none at all, for renouncing war—except to those for whom the notions of valor and sacrifice have been emptied of meaning and credibility. The destructiveness of war—short of total destruction, which is not war but suicide—is not in itself an argument against waging war unless one thinks (as few people actually do think) that violence is always unjustifiable, that force is always

and in all circumstances wrong—wrong because, as Simone Weil affirms in her sublime essay on war, "The Iliad, or The Poem of Force" (1940), violence turns anybody subjected to it into a thing.[1] No, retort those who in a given situation see no alternative to armed struggle, violence can exalt someone subjected to it into a martyr or a hero.

In fact, there are many uses of the innumerable opportunities a modern life supplies for regarding—at a distance, through the medium of photography—other people's pain. Photographs of an atrocity may give rise to opposing responses. A call for peace. A cry for revenge. Or simply the bemused awareness, continually restocked by photo-

1. Her condemnation of war notwithstanding, Weil sought to participate in the defense of the Spanish Republic and in the fight against Hitler's Germany. In 1936 she went to Spain as a noncombatant volunteer in an international brigade; in 1942 and early 1943, a refugee in London and already ill, she worked at the office of the Free French and hoped to be sent on a mission in Occupied France. (She died in an English sanatorium in August 1943.)

graphic information, that terrible things happen. Who can forget the three color pictures by Tyler Hicks that *The New York Times* ran across the upper half of the first page of its daily section devoted to America's new war, "A Nation Challenged," on November 13, 2001? The triptych depicted the fate of a wounded Taliban soldier in uniform who had been found in a ditch by Northern Alliance soldiers advancing toward Kabul. First panel: being dragged on his back by two of his captors—one has grabbed an arm, the other a leg—along a rocky road. Second panel (the camera is very near): surrounded, gazing up in terror as he is being pulled to his feet. Third panel: at the moment of death, supine with arms outstretched and knees bent, naked and bloodied from the waist down, being finished off by the military mob that has gathered to butcher him. An ample reservoir of stoicism is needed to get through the great newspaper of record each morning, given the likelihood of seeing photographs that could make you cry. And the pity and disgust that pictures like Hicks's

inspire should not distract you from asking what pictures, whose cruelties, whose deaths are *not* being shown.

For a long time some people believed that if the horror could be made vivid enough, most people would finally take in the outrageousness, the insanity of war.

Fourteen years before Woolf published *Three Guineas*—in 1924, on the tenth anniversary of the national mobilization in Germany for the First World War—the conscientious objector Ernst Friedrich published his *Krieg dem Kriege!* (*War Against War!*). This is photography as shock therapy: an album of more than one hundred and eighty photographs mostly drawn from German military and medical archives, many of which were deemed unpublishable by government censors while the war was on. The book starts with pictures of toy soldiers, toy cannons, and other delights of male children everywhere, and concludes with pictures taken in military cemeteries.

Between the toys and the graves, the reader
has an excruciating photo-tour of four years
of ruin, slaughter, and degradation: pages
of wrecked and plundered churches and
castles, obliterated villages, ravaged forests,
torpedoed passenger steamers, shattered
vehicles, hanged conscientious objectors,
half-naked prostitutes in military brothels,
soldiers in death agonies after a poison-gas
attack, skeletal Armenian children. Almost
all the sequences in *War Against War!* are
difficult to look at, notably the pictures
of dead soldiers belonging to the various
armies putrefying in heaps on fields and
roads and in the front-line trenches. But
surely the most unbearable pages in this
book, the whole of which was designed to
horrify and demoralize, are in the section
titled "The Face of War," twenty-four close-
ups of soldiers with huge facial wounds.
And Friedrich did not make the mistake of
supposing that heartrending, stomach-
turning pictures would simply speak for
themselves. Each photograph has an impas-
sioned caption in four languages (German,
French, Dutch, and English), and the wick-

edness of militarist ideology is excoriated
and mocked on every page. Immediately de-
nounced by the government and by veter-
ans' and other patriotic organizations—in
some cities the police raided bookstores,
and lawsuits were brought against the pub-
lic display of the photographs—Friedrich's
declaration of war against war was acclaimed
by left-wing writers, artists, and intellectu-
als, as well as by the constituencies of the nu-
merous antiwar leagues, who predicted that
the book would have a decisive influence on
public opinion. By 1930, *War Against War!*
had gone through ten editions in Germany
and been translated into many languages.

In 1938, the year of Woolf's *Three Guin-
eas*, the great French director Abel Gance
featured in close-up some of the mostly hid-
den population of hideously disfigured ex-
combatants—*les gueules cassées* ("the broken
mugs") they were nicknamed in French—at
the climax of his new *J'accuse*. (Gance had
made an earlier, primitive version of his
incomparable antiwar film, with the same
hallowed title, in 1918–19.) As in the final
section of Friedrich's book, Gance's film

ends in a new military cemetery, not just to remind us of how many millions of young men were sacrificed to militarism and ineptitude between 1914 and 1918 in the war cheered on as "the war to end all wars," but to advance the sacred judgment these dead would surely bring against Europe's politicians and generals could they know that, twenty years later, another war was imminent. *"Morts de Verdun, levez-vous!"* (Rise, dead of Verdun!) cries the deranged veteran who is the protagonist of the film, and he repeats his summons in German and in English: "Your sacrifices were in vain!" And the vast mortuary plain disgorges its multitudes, an army of shambling ghosts in rotted uniforms with mutilated faces, who rise from their graves and set out in all directions, causing mass panic among the populace already mobilized for a new pan-European war. "Fill your eyes with this horror! It is the only thing that can stop you!" the madman cries to the fleeing multitudes of the living, who reward him with a martyr's death, after which he joins his

dead comrades: a sea of impassive ghosts overrunning the cowering future combatants and victims of *la guerre de demain*. War beaten back by apocalypse.

And the following year the war came.

2

BEING A SPECTATOR of calamities taking place in another country is a quintessential modern experience, the cumulative offering by more than a century and a half's worth of those professional, specialized tourists known as journalists. Wars are now also living room sights and sounds. Information about what is happening elsewhere, called "news," features conflict and violence—"If it bleeds, it leads" runs the venerable guideline of tabloids and twenty-four-hour headline news shows—to which the response is compassion, or indignation, or titillation, or approval, as each misery heaves into view.

How to respond to the steadily increasing flow of information about the agonies of war was already an issue in the late nineteenth century. In 1899, Gustave Moynier, the first president of the International Committee of the Red Cross, wrote:

> We now know what happens every day throughout the whole world . . . the descriptions given by daily journalists put, as it were, those in agony on fields of battle under the eyes of [newspaper] readers and their cries resonate in their ears . . .

Moynier was thinking of the soaring casualties of combatants on all sides, whose sufferings the Red Cross was founded to succor impartially. The killing power of armies in battle had been raised to a new magnitude by weapons introduced shortly after the Crimean War (1854–56), such as the breech-loading rifle and the machine gun. But though the agonies of the battlefield had become present as never before to those who would only read about them in the press, it was obviously an exaggeration, in 1899, to say that one knew what happened "every day throughout the whole world." And, though the sufferings endured in faraway wars now do assault our eyes and ears even as they happen, it is still an exaggeration. What is called in news parlance

"the world"—"You give us twenty-two minutes, we'll give you the world," one radio network intones several times an hour—is (unlike the world) a very small place, both geographically and thematically, and what is thought worth knowing about it is expected to be transmitted tersely and emphatically.

Awareness of the suffering that accumulates in a select number of wars happening elsewhere is something constructed. Principally in the form that is registered by cameras, it flares up, is shared by many people, and fades from view. In contrast to a written account—which, depending on its complexity of thought, reference, and vocabulary, is pitched at a larger or smaller readership—a photograph has only one language and is destined potentially for all.

In the first important wars of which there are accounts by photographers, the Crimean War and the American Civil War, and in every other war until the First World War, combat itself was beyond the camera's ken. As for the war photographs published between 1914 and 1918, nearly all anonymous, they were—insofar as they did

convey something of the terrors and the devastation—generally in the epic mode, and were usually depictions of an aftermath: the corpse-strewn or lunar landscapes left by trench warfare; the gutted French villages the war had passed through. The photographic monitoring of war as we know it had to wait a few more years for a radical upgrade of professional equipment: lightweight cameras, such as the Leica, using 35-mm film that could be exposed thirty-six times before the camera needed to be reloaded. Pictures could now be taken in the thick of battle, military censorship permitting, and civilian victims and exhausted, begrimed soldiers studied up close. The Spanish Civil War (1936–39) was the first war to be witnessed ("covered") in the modern sense: by a corps of professional photographers at the lines of military engagement and in the towns under bombardment, whose work was immediately seen in newspapers and magazines in Spain and abroad. The war America waged in Vietnam, the first to be witnessed day after day by television cameras, introduced the

home front to new tele-intimacy with death and destruction. Ever since, battles and massacres filmed as they unfold have been a routine ingredient of the ceaseless flow of domestic, small-screen entertainment. Creating a perch for a particular conflict in the consciousness of viewers exposed to dramas from everywhere requires the daily diffusion and rediffusion of snippets of footage about the conflict. The understanding of war among people who have not experienced war is now chiefly a product of the impact of these images.

Something becomes real—to those who are elsewhere, following it as "news"—by being photographed. But a catastrophe that is experienced will often seem eerily like its representation. The attack on the World Trade Center on September 11, 2001, was described as "unreal," "surreal," "like a movie," in many of the first accounts of those who escaped from the towers or watched from nearby. (After four decades of big-budget Hollywood disaster films, "It felt like a movie" seems to have displaced the way survivors of a catastrophe used to express the

short-term unassimilability of what they had gone through: "It felt like a dream.")

Nonstop imagery (television, streaming video, movies) is our surround, but when it comes to remembering, the photograph has the deeper bite. Memory freeze-frames; its basic unit is the single image. In an era of information overload, the photograph provides a quick way of apprehending something and a compact form for memorizing it. The photograph is like a quotation, or a maxim or proverb. Each of us mentally stocks hundreds of photographs, subject to instant recall. Cite the most famous photograph taken during the Spanish Civil War, the Republican soldier "shot" by Robert Capa's camera at the same moment he is hit by an enemy bullet, and virtually everyone who has heard of that war can summon to mind the grainy black-and-white image of a man in a white shirt with rolled-up sleeves collapsing backward on a hillock, his right arm flung behind him as his rifle leaves his grip; about to fall, dead, onto his own shadow.

It is a shocking image, and that is the

point. Conscripted as part of journalism, images were expected to arrest attention, startle, surprise. As the old advertising slogan of *Paris Match*, founded in 1949, had it: "The weight of words, the shock of photos." The hunt for more dramatic (as they're often described) images drives the photographic enterprise, and is part of the normality of a culture in which shock has become a leading stimulus of consumption and source of value. "Beauty will be convulsive, or it will not be," proclaimed André Breton. He called this aesthetic ideal "surrealist," but in a culture radically revamped by the ascendancy of mercantile values, to ask that images be jarring, clamorous, eye-opening seems like elementary realism as well as good business sense. How else to get attention for one's product or one's art? How else to make a dent when there is incessant exposure to images, and overexposure to a handful of images seen again and again? The image as shock and the image as cliché are two aspects of the same presence. Sixty-five years ago, all photographs were novelties to some degree. (It would have

Benjamin
Aitho MR
who wrote
people as
icons/
emblems

been inconceivable to Woolf—who did appear on the cover of *Time* in 1937—that one day her face would become a much-reproduced image on T-shirts, coffee mugs, book bags, refrigerator magnets, mouse pads.) Atrocity photographs were scarce in the winter of 1936–37: the depiction of war's horrors in the photographs Woolf evokes in *Three Guineas* seemed almost like clandestine knowledge. Our situation is altogether different. The ultra-familiar, ultra-celebrated image—of an agony, of ruin—is an unavoidable feature of our camera-mediated knowledge of war.

Ever since cameras were invented in 1839, photography has kept company with death. Because an image produced with a camera is, literally, a trace of something brought before the lens, photographs were superior to any painting as a memento of the vanished past and the dear departed. To seize death in the making was another matter: the camera's reach remained limited as long

as it had to be lugged about, set down, steadied. But once the camera was emancipated from the tripod, truly portable, and equipped with a range finder and a variety of lenses that permitted unprecedented feats of close observation from a distant vantage point, picture-taking acquired an immediacy and authority greater than any verbal account in conveying the horror of mass-produced death. If there was one year when the power of photographs to define, not merely record, the most abominable realities trumped all the complex narratives, surely it was 1945, with the pictures taken in April and early May at Bergen-Belsen, Buchenwald, and Dachau in the first days after the camps were liberated, and those taken by Japanese witnesses such as Yosuke Yamahata in the days following the incineration of the populations of Hiroshima and Nagasaki in early August.

The era of shock—for Europe—began three decades earlier, in 1914. Within a year of the start of the Great War, as it was known for a while, much that had been taken for granted came to seem fragile, even

Why?

undefendable. The nightmare of suicidally lethal military engagement from which the warring countries were unable to extricate themselves—above all, the daily slaughter in the trenches on the Western Front— seemed to many to have exceeded the capacity of words to describe.[2] In 1915, none other than the august master of the intricate cocooning of reality in words, the magician of the verbose, Henry James, declared to *The New York Times*: "One finds it in the midst of all this as hard to apply one's words as to endure one's thoughts. The war has used up words; they have weakened, they have deteriorated . . ." And Walter Lippmann wrote in 1922: "Photographs have the kind of authority over imagination today, which the printed word had yester-

2. On the first day of the Battle of the Somme, July 1, 1916, sixty thousand British soldiers were killed or gravely wounded—thirty thousand of these in the first half-hour. At the end of four and a half months of battle, 1.3 million casualties had been sustained by both sides, and the British and French front line had advanced by five miles.

day, and the spoken word before that. They seem utterly real."

Photographs had the advantage of uniting two contradictory features. Their credentials of objectivity were inbuilt. Yet they always had, necessarily, a point of view. They were a record of the real—incontrovertible, as no verbal account, however impartial, could be—since a machine was doing the recording. And they bore witness to the real—since a person had been there to take them.

Photographs, Woolf claims, "are not an argument; they are simply a crude statement of fact addressed to the eye." The truth is they are not "simply" anything, and certainly not regarded just as facts, by Woolf or anyone else. For, as she immediately adds, "the eye is connected with the brain; the brain with the nervous system. That system sends its messages in a flash through every past memory and present feeling." This sleight of hand allows photographs to be both objective record and personal testimony, both a faithful copy or transcription of an actual moment of reality and an interpretation of

that reality—a feat literature has long aspired to, but could never attain in this literal sense.

Those who stress the evidentiary punch of image-making by cameras have to finesse the question of the subjectivity of the image-maker. For the photography of atrocity, people want the weight of witnessing without the taint of artistry, which is equated with insincerity or mere contrivance. Pictures of hellish events seem more authentic when they don't have the look that comes from being "properly" lighted and composed, because the photographer either is an amateur or—just as serviceable—has adopted one of several familiar anti-art styles. By flying low, artistically speaking, such pictures are thought to be less manipulative—all widely distributed images of suffering now stand under that suspicion—and less likely to arouse facile compassion or identification.

The less polished pictures are not only welcomed as possessing a special kind of authenticity. Some may compete with the best, so permissive are the standards for a memorable, eloquent picture. This was il-

lustrated by an exemplary show of photographs documenting the destruction of the World Trade Center that opened in storefront space in Manhattan's SoHo in late September 2001. The organizers of *Here Is New York*, as the show was resonantly titled, had sent out a call inviting everyone—amateur and professional—who had images of the attack and its aftermath to bring them in. There were more than a thousand responses in the first weeks, and from everyone who submitted photographs, at least one picture was accepted for exhibit. Unattributed and uncaptioned, they were all on display, hanging in two narrow rooms or included in a slide show on one of the computer monitors (and on the exhibit's website), and for sale, in the form of a high-quality ink-jet print, for the same small sum, twenty-five dollars (proceeds to a fund benefiting the children of those killed on September 11). After the purchase was completed, the buyer could learn whether she had perhaps bought a Gilles Peress (who was one of the organizers of the show) or a James Nachtwey or a picture by a retired

schoolteacher who, leaning out the bedroom window of her rent-controlled Village apartment with her point-and-shoot, had caught the north tower as it fell. "A Democracy of Photographs," the subtitle of the exhibit, suggested that there was work by amateurs as good as the work of the seasoned professionals who participated. And indeed there was—which proves something about photography, if not necessarily something about cultural democracy. Photography is the only major art in which professional training and years of experience do not confer an insuperable advantage over the untrained and inexperienced—this for many reasons, among them the large role that chance (or luck) plays in the taking of pictures, and the bias toward the spontaneous, the rough, the imperfect. (There is no comparable level playing field in literature, where virtually nothing owes to chance or luck and where refinement of language usually incurs no penalty; or in the performing arts, where genuine achievement is unattainable without exhaustive training and daily practice; or in filmmaking, which

[handwritten margin notes: "Could this have been possible in a different medium", "B/c many mediums would challenge this memory essay", "That's true but implicit often seems better than obvious"]

is not guided to any significant degree by the anti-art prejudices of much of contemporary art photography.)

Whether the photograph is understood as a naïve object or the work of an experienced artificer, its meaning—and the viewer's response—depends on how the picture is identified or misidentified; that is, on words. The organizing idea, the moment, the place, and the devoted public made this exhibit something of an exception. The crowds of solemn New Yorkers who stood in line for hours on Prince Street every day throughout the fall of 2001 to see *Here Is New York* had no need of captions. They had, if anything, a surfeit of understanding of what they were looking at, building by building, street by street—the fires, the detritus, the fear, the exhaustion, the grief. But one day captions will be needed, of course. And the misreadings and the misrememberings, and new ideological uses for the pictures, will make their difference.

Normally, if there is any distance from the subject, what a photograph "says" can be read in several ways. Eventually, one reads

into the photograph what it *should* be say-ing. Splice into a long take of a perfectly deadpan face the shots of such disparate material as a bowl of steaming soup, a woman in a coffin, a child playing with a toy bear, and the viewers—as the first theorist of film, Lev Kuleshov, famously demon-strated in his workshop in Moscow in the 1920s—will marvel at the subtlety and range of the actor's expressions. In the case of still photographs, we use what we know of the drama of which the picture's sub-ject is a part. "Land Distribution Meeting, Extremadura, Spain, 1936," the much-reproduced photograph by David Seymour ("Chim") of a gaunt woman standing with a baby at her breast looking upward (in-tently? apprehensively?), is often recalled as showing someone fearfully scanning the sky for attacking planes. The expressions on her face and the faces around her seem charged with apprehensiveness. Memory has altered the image, according to memory's needs, conferring emblematic status on Chim's picture not for what it is described as show-ing (an outdoor political meeting, which

took place four months before the war started) but for what was soon to happen in Spain that would have such enormous resonance: air attacks on cities and villages, for the sole purpose of destroying them completely, being used as a weapon of war for the first time in Europe.[3] Before long

3. Nothing in Franco's barbarous conduct of the war is as well remembered as these raids, mostly executed by the unit of the German air force sent by Hitler to aid Franco, the Condor Legion, and memorialized in Picasso's Guernica. But they were not without precedent. During the First World War, there had been some sporadic, relatively ineffective bombing; for example, the Germans conducted raids from Zeppelins, then from planes, on a number of cities, including London, Paris, and Antwerp. Far more lethally—starting with the attack by Italian fighter planes near Tripoli in October 1911— European nations had been bombing their colonies. So-called "air control operations" were favored as an economical alternative to the costly practice of maintaining large garrisons to police Britain's more restive possessions. One of these was Iraq, which (along with Palestine) had gone to Britain as part of the spoils of victory when the Ottoman Empire was dismembered after the First World War. Between 1920 and 1924, the recently formed Royal Air Force

the sky did harbor planes that were drop-
ping bombs on landless peasants like those
in the photograph. (Look again at the
nursing mother, at her furrowed brow, her
squint, her half-open mouth. Does she still
seem as apprehensive? Doesn't it now seem

regularly targeted Iraqi villages, often remote set-
tlements, where the rebellious natives might try to
find shelter, with the raids "carried on continuously
by day and night, on houses, inhabitants, crops, and
cattle," according to the tactics outlined by one
RAF wing commander.

What horrified public opinion in the 1930s was
that the slaughter of civilians from the air was hap-
pening in Spain; these sorts of things were not sup-
posed to happen *here*. As David Rieff has pointed
out, a similar feeling drew attention to the atrocities
committed by the Serbs in Bosnia in the 1990s,
from the death camps such as Omarska early in the
war to the massacre in Srebrenica, where most of
the male inhabitants who had not been able to
flee—more than eight thousand men and boys—
were rounded up, gunned down, and pushed into
mass graves once the town was abandoned by the
Dutch battalion of the United Nations Protection
Force and surrendered to General Ratko Mladić:
these sorts of things are not supposed to happen
here, in Europe, *any more*.

as if she is squinting because the sun is in her eyes?)

The photographs Woolf received are treated as a window on the war: transparent views of their subject. It was of no interest to her that each had an "author"—that photographs represent the view of *someone*—although it was precisely in the late 1930s that the profession of bearing individual witness to war and war's atrocities with a camera was forged. Once, war photography mostly appeared in daily and weekly newspapers. (Newspapers had been printing photographs since 1880.) Then, in addition to the older popular magazines from the late nineteenth century such as *National Geographic* and *Berliner Illustrierte Zeitung* that used photographs as illustrations, large-circulation weekly magazines arrived, notably the French *Vu* (in 1929), the *American Life* (in 1936), and the British *Picture Post* (in 1938), that were entirely devoted to pictures (accompanied by brief texts keyed to the photos) and "picture stories"—at least four or five pictures by the same photographer trailed by a story

that further dramatized the images. In a newspaper, it was the picture—and there was only one—that accompanied the story.

Further, when published in a newspaper, the war photograph was surrounded by words (the article it illustrated and other articles), while in a magazine, it was more likely to be adjacent to a competing image that was peddling something. When Capa's at-the-moment-of-death picture of the Republican soldier appeared in *Life* on July 12, 1937, it occupied the whole of the right page; facing it on the left was a full-page advertisement for Vitalis, a men's hair cream, with a small picture of someone exerting himself at tennis and a large portrait of the same man in a white dinner jacket sporting a head of neatly parted, slicked-down, lustrous hair.[4] The double spread—

4. Capa's already much admired picture, taken (according to the photographer) on September 5, 1936, was originally published in *Vu* on September 23, 1936, above a second photograph, taken from the same angle and in the same light, of another Republican soldier collapsing, his rifle leaving his right hand, on the same spot on the hillside; that

with each use of the camera implying the invisibility of the other—seems not just bizarre but curiously dated now.

In a system based on the maximal reproduction and diffusion of images, witnessing requires the creation of star witnesses, renowned for their bravery and zeal in procuring important, disturbing photographs. One of the first issues of *Picture Post* (December 3, 1938), which ran a portfolio of Capa's Spanish Civil War pictures, used as its cover a head shot of the handsome photographer in profile holding a camera to his face: "The Greatest War Photographer in the World: Robert Capa." War photographers inherited what glamour going to war still had among the anti-bellicose, especially when the war was felt to be one of those rare conflicts in which someone of conscience would be impelled to take sides. (The war in Bosnia, nearly sixty years later, inspired similar partisan feelings among the journalists who

photograph was never reprinted. The first picture also appeared soon after in a newspaper, *Paris-Soir*.

lived for a time in besieged Sarajevo.) And, in contrast to the 1914–18 war, which, it was clear to many of the victors, had been a colossal mistake, the second "world war" was unanimously felt by the winning side to have been a necessary war, a war that had to be fought.

Photojournalism came into its own in the early 1940s—wartime. This least controversial of modern wars, whose justness was sealed by the full revelation of Nazi evil as the war ended in 1945, offered photojournalists a new legitimacy, one that had little place for the left-wing dissidence that had informed much of the serious use of photographs in the interwar period, including Friedrich's *War Against War!* and the early pictures by Capa, the most celebrated figure in a generation of politically engaged photographers whose work centered on war and victimhood. In the wake of the new mainstream liberal consensus about the tractability of acute social problems, issues of the photographer's own livelihood and independence moved to the foreground. One result was the formation

by Capa with a few friends (who included Chim and Henri Cartier-Bresson) of a cooperative, the Magnum Photo Agency, in Paris in 1947. The immediate purpose of Magnum—which quickly became the most influential and prestigious consortium of photojournalists—was a practical one: to represent venturesome freelance photographers to the picture magazines sending them on assignments. At the same time, Magnum's charter, moralistic in the way of other founding charters of the new international organizations and guilds created in the immediate postwar period, spelled out an enlarged, ethically weighted mission for photojournalists: to chronicle their own time, be it a time of war or a time of peace, as fair-minded witnesses free of chauvinistic prejudices.

In Magnum's voice, photography declared itself a global enterprise. The photographer's nationality and national journalistic affiliation were, in principle, irrelevant. The photographer could be from anywhere. And his or her beat was "the world." The photographer was a rover, with wars of

unusual interest (for there were many wars) a favorite destination.

The memory of war, however, like all memory, is mostly local. Armenians, the majority in diaspora, keep alive the memory of the Armenian genocide of 1915; Greeks don't forget the sanguinary civil war in Greece that raged through the late 1940s. But for a war to break out of its immediate constituency and become a subject of international attention, it must be regarded as something of an exception, as wars go, and represent more than the clashing interests of the belligerents themselves. Most wars do not acquire the requisite fuller meaning. An example: the Chaco War (1932–35), a butchery engaged in by Bolivia (population one million) and Paraguay (three and a half million) that took the lives of one hundred thousand soldiers, and which was covered by a German photojournalist, Willi Ruge, whose superb close-up battle pictures are as forgotten as that war. But the Spanish Civil War in the second half of the 1930s, the Serb and Croat wars against Bosnia in the mid-1990s, the drastic worsening of

the Israeli-Palestinian conflict that began
in 2000—these contests were guaranteed
the attention of many cameras because they
were invested with the meaning of larger
struggles: the Spanish Civil War because it
was a stand against the fascist menace,
and (in retrospect) a dress rehearsal for the
coming European, or "world," war; the
Bosnian war because it was the stand of a
small, fledgling southern European coun-
try wishing to remain multicultural as well
as independent against the dominant power
in the region and its neo-fascist program of
ethnic cleansing; and the ongoing conflict
over the character and governance of terri-
tories claimed by both Israeli Jews and
Palestinians because of a variety of flash-
points, starting with the inveterate fame or
notoriety of the Jewish people, the unique
resonance of the Nazi extermination of Eu-
ropean Jewry, the crucial support that the
United States gives to the state of Israel,
and the identification of Israel as an
apartheid state maintaining a brutal do-
minion over the lands captured in 1967. In
the meantime, far crueler wars in which

civilians are relentlessly slaughtered from the air and massacred on the ground (the decades-long civil war in Sudan, the Iraqi campaigns against the Kurds, the Russian invasions and occupation of Chechnya) have gone relatively underphotographed.

The memorable sites of suffering documented by admired photographers in the 1950s, 1960s, and early 1970s were mostly in Asia and Africa—Werner Bischof's photographs of famine victims in India, Don McCullin's pictures of victims of war and famine in Biafra, W. Eugene Smith's photographs of the victims of the lethal pollution of a Japanese fishing village. The Indian and African famines were not just "natural" disasters; they were preventable; they were crimes of great magnitude. And what happened in Minamata was obviously a crime: the Chisso Corporation knew it was dumping mercury-laden waste into the bay. (After a year of taking pictures, Smith was severely and permanently injured by Chisso goons who were ordered to put an end to his camera inquiry.) But war is the largest crime, and since the mid-1960s,

most of the best-known photographers covering wars have thought their role was to show war's "real" face. The color photographs of tormented Vietnamese villagers and wounded American conscripts that Larry Burrows took and *Life* published, starting in 1962, certainly fortified the outcry against the American presence in Vietnam. (In 1971 Burrows was shot down with three other photographers aboard a U.S. military helicopter flying over the Ho Chi Minh Trail in Laos. *Life*, to the dismay of many who, like me, had grown up with and been educated by its revelatory pictures of war and of art, closed in 1972.) Burrows was the first important photographer to do a whole war in color—another gain in verisimilitude, that is, shock. In the current political mood, the friendliest to the military in decades, the pictures of wretched hollow-eyed GIs that once seemed subversive of militarism and imperialism may seem inspirational. Their revised subject: ordinary American young men doing their unpleasant, ennobling duty.

Exception made for Europe today, which

has claimed the right to opt out of war-making, it remains as true as ever that most people will not question the rationalizations offered by their government for starting or continuing a war. It takes some very peculiar circumstances for a war to become genuinely unpopular. (The prospect of being killed is not necessarily one of them.) When it does, the material gathered by photographers, which they may think of as unmasking the conflict, is of great use. Absent such a protest, the same antiwar photograph may be read as showing pathos, or heroism, admirable heroism, in an unavoidable struggle that can be concluded only by victory or by defeat. The photographer's intentions do not determine the meaning of the photograph, which will have its own career, blown by the whims and loyalties of the diverse communities that have use for it.

3

WHAT DOES IT MEAN to protest suffering, as distinct from acknowledging it? *obviously not really point / + more than acknowledging* *explore*

The iconography of suffering has a long pedigree. The sufferings most often deemed worthy of representation are those understood to be the product of wrath, divine or human. (Suffering from natural causes, such as illness or childbirth, is scantily represented in the history of art; that caused by accident, virtually not at all—as if there were no such thing as suffering by inadvertence or misadventure.) The statue group of the writhing Laocoön and his sons, the innumerable versions in painting and sculpture of the Passion of Christ, and the inexhaustible visual catalogue of the fiendish executions of the Christian martyrs—these are surely intended to move and excite, and to instruct and exemplify. The viewer may commiserate with the sufferer's pain—and, in the case of the Christian

If foreordained & blessed martyrdom no cause / If legitimate punishment—no cause

saints, feel admonished or inspired by model faith and fortitude—but these are destinies beyond deploring or contesting.

It seems that the appetite for pictures showing bodies in pain is as keen, almost, as the desire for ones that show bodies naked. For many centuries, in Christian art, depictions of hell offered both of these elemental satisfactions. On occasion, the pretext might be a Biblical decapitation anecdote (Holofernes, John the Baptist), or massacre yarn (the newborn Hebrew boys, the eleven thousand virgins), or some such, with the status of a real historical event and of an implacable fate. There was also the repertoire of hard-to-look-at cruelties from classical antiquity—the pagan myths, even more than the Christian stories, offer something for every taste. No moral charge attaches to the representation of these cruelties. Just the provocation: can you look at this? There is the satisfaction of being able to look at the image without flinching. There is the pleasure of flinching.

To shudder at Goltzius's rendering, in his etching *The Dragon Devouring the Com-*

panions of Cadmus (1588), of a man's face being chewed off his head is very different from shuddering at a photograph of a First World War veteran whose face has been shot away. One horror has its place in a complex subject—figures in a landscape— that displays the artist's skill of eye and hand. The other is a camera's record, from very near, of a real person's unspeakably awful mutilation; that and nothing else. An invented horror can be quite overwhelming. (I, for one, find it difficult to look at Titian's great painting of the flaying of Marsyas, or indeed at any picture of this subject.) But there is shame as well as shock in looking at the close-up of a real horror. Perhaps the only people with the right to look at images of suffering of this extreme order are those who could do something to alleviate it—say, the surgeons at the military hospital where the photograph was taken—or those who could learn from it. The rest of us are voyeurs, whether or not we mean to be.

In each instance, the gruesome invites us to be either spectators or cowards, unable to look. Those with the stomach to look are

playing a role authorized by many glorious depictions of suffering. <u>Torment, a canonical subject in art, is often represented in painting as a spectacle, something being watched (or ignored) by other people. The implication is: no, it cannot be stopped—and the mingling of inattentive with attentive onlookers underscores this.</u>

The practice of representing atrocious suffering as something to be deplored, and, if possible, stopped, enters the history of images with a specific subject: the sufferings endured by a civilian population at the hands of a victorious army on the rampage. It is a quintessentially secular subject, which emerges in the seventeenth century, when contemporary realignments of power become material for artists. In 1633 Jacques Callot published a suite of eighteen etchings titled *Les Misères et les Malheurs de la Guerre* (*The Miseries and Misfortunes of War*), which depicted the atrocities committed against civilians by French troops during the invasion and occupation of his native Lorraine in the early 1630s. (Six small etchings on the same subject that Callot had

executed prior to the large series appeared in 1635, the year of his death.) The view is wide and deep; these are large scenes with many figures, scenes from a history, and each caption is a sententious comment in verse on the various energies and dooms portrayed in the images. Callot begins with a plate showing the recruitment of soldiers; brings into view ferocious combat, massacre, pillage, and rape, the engines of torture and execution (strappado, gallows tree, firing squad, stake, wheel), the revenge of the peasants on the soldiers; and ends with a distribution of rewards. The insistence in plate after plate on the savagery of a conquering army is startling and without precedent, but the French soldiers are only the leading malefactors in the orgy of violence, and there is room in Callot's Christian humanist sensibility not just to mourn the end of the independent Duchy of Lorraine but to record the postwar plight of destitute soldiers who squat on the side of a road begging for alms.

Callot had his successors, such as Hans Ulrich Franck, a minor German artist, who,

in 1643, toward the end of the Thirty Years' War, began making what would amount to (by 1656) twenty-five etchings depicting soldiers killing peasants. But the preeminent concentration on the horrors of war and the vileness of soldiers run amok is Goya's, in the early nineteenth century. *Los Desastres de la Guerra* (*The Disasters of War*), a numbered sequence of eighty-three etchings made between 1810 and 1820 (and first published, all but three plates, in 1863, thirty-five years after his death), depicts the atrocities perpetrated by Napoleon's soldiers who invaded Spain in 1808 to quell the insurrection against French rule. Goya's images move the viewer close to the horror. All the trappings of the spectacular have been eliminated: the landscape is an atmosphere, a darkness, barely sketched in. War is not a spectacle. And Goya's print series is not a narrative: each image, captioned with a brief phrase lamenting the wickedness of the invaders and the monstrousness of the suffering they inflicted, stands independently of the others. The cumulative effect is devastating.

The ghoulish cruelties in *The Disasters of War* are meant to awaken, shock, wound the viewer. Goya's art, like Dostoyevsky's, seems a turning point in the history of moral feelings and of sorrow—as deep, as original, as demanding. With Goya, a new standard for responsiveness to suffering enters art. (And new subjects for fellow-feeling: as in, for example, his painting of an injured laborer being carried away from a building site.) The account of war's cruelties is fashioned as an assault on the sensibility of the viewer. The expressive phrases in script below each image comment on the provocation. While the image, like every image, is an invitation to look, the caption, more often than not, insists on the difficulty of doing just that. A voice, presumably the artist's, badgers the viewer: can you bear to look at this? One caption declares: One can't look (*No se puede mirar*). Another says: This is bad (*Esto es malo*). Another retorts: This is worse (*Esto es peor*). Another shouts: This is the worst! (*Esto es lo peor!*). Another declaims: Barbarians! (*Bárbaros!*). What madness! (*Que locura!*), cries another. And another: This is

too much! (*Fuerte cosa es!*). And another: Why? (*Por qué?*).

The caption of a photograph is traditionally neutrally informative: a date, a place, names. A reconnaissance photograph from the First World War (the first war in which cameras were used extensively for military intelligence) was unlikely to be captioned "Can't wait to overrun this!" or the X-ray of a multiple fracture to be annotated "Patient will probably have a limp!" Nor should there be a need to speak for the photograph in the photographer's voice, offering assurances of the image's veracity, as Goya does in *The Disasters of War*, writing beneath one image: I saw this (*Yo lo vi*). And beneath another: This is the truth (*Esto es lo verdadero*). Of course the photographer saw it. And unless there's been some tampering or misrepresenting, it is the truth.

Ordinary language fixes the difference between handmade images like Goya's and photographs by the convention that artists "make" drawings and paintings while photographers "take" photographs. But the photographic image, even to the extent that

it is a trace (not a construction made out of disparate photographic traces), cannot be simply a transparency of something that happened. It is always the image that some-one chose; to photograph is to frame, and to frame is to exclude. Moreover, fiddling with pictures long antedates the era of digital photography and Photoshop manipulations: it has always been possible for a photo-graph to misrepresent. A painting or drawing is judged a fake when it turns out not to be by the artist to whom it had been attributed. A photograph—or a filmed document available on television or the in-ternet—is judged a fake when it turns out to be deceiving the viewer about the scene it purports to depict.

That the atrocities perpetrated by the French soldiers in Spain didn't happen ex-actly as pictured—say, that the victim didn't look just so, that it didn't happen next to a tree—hardly disqualifies *The Disasters of War*. Goya's images are a synthesis. They claim: things *like* this happened. In contrast, a single photograph or filmstrip claims to represent exactly what was before the

camera's lens. A photograph is supposed not to evoke but to show. That is why photographs, unlike handmade images, can count as evidence. But evidence of what? The suspicion that Capa's "Death of a Republican Soldier"—titled "The Falling Soldier" in the authoritative compilation of Capa's work—may not show what it is said to show (one hypothesis is that it records a training exercise near the front line) continues to haunt discussions of war photography. Everyone is a literalist when it comes to photographs.

Images of the sufferings endured in war are so widely disseminated now that it is easy to forget how recently such images became what is expected from photographers of note. Historically, photographers have offered mostly positive images of the warrior's trade, and of the satisfactions of starting a war or continuing to fight one. If governments had their way, war photography, like

most war poetry, would drum up support for soldiers' sacrifice.

Indeed, war photography begins with such a mission, such a disgrace. The war was the Crimean War, and the photographer, Roger Fenton, invariably called the first war photographer, was no less than that war's "official" photographer, having been sent to the Crimea in early 1855 by the British government at the instigation of Prince Albert. Acknowledging the need to counteract the alarming printed accounts of the unanticipated risks and privations endured by the British soldiers dispatched there the previous year, the government had invited a well-known professional photographer to give another, more positive impression of the increasingly unpopular war.

Edmund Gosse, in *Father and Son* (1907), his memoir of a mid-nineteenth-century English childhood, relates how the Crimean War penetrated even his stringently pious, unworldly family, which belonged to an evangelical sect called the Plymouth Brethren:

The declaration of war with Russia brought the first breath of outside life into our Calvinist cloister. My parents took in a daily newspaper, which they had never done before, and events in picturesque places, which my Father and I looked out on the map, were eagerly discussed.

War was and still is the most irresistible—and picturesque—news. (Along with that invaluable substitute for war, international sports.) But this war was more than news. It was bad news. The authoritative, pictureless London newspaper to which Gosse's parents had succumbed, *The Times*, attacked the military leadership whose incompetence was responsible for the war's dragging on, with so much loss of British life. The toll on the soldiers from causes other than combat was horrendous—twenty-two thousand died of illnesses; many thousands lost limbs to frostbite during the long Russian winter of the protracted siege of Sebastopol—and several of the military engagements were disasters. It

was still winter when Fenton arrived in the Crimea for a four-month stay, having contracted to publish his photographs (in the form of engravings) in a less venerable and less critical weekly paper, *The Illustrated London News*, exhibit them in a gallery, and market them as a book upon his return home.

Under instructions from the War Office not to photograph the dead, the maimed, or the ill, and precluded from photographing most other subjects by the cumbersome technology of picture-taking, Fenton went about rendering the war as a dignified all-male group outing. With each image requiring a separate chemical preparation in the darkroom and with exposure time as long as fifteen seconds, Fenton could photograph British officers in open-air confabulation or common soldiers tending the cannons only after asking them to stand or sit together, follow his directions, and hold still. His pictures are tableaux of military life behind the front lines; the war—movement, disorder, drama—stays off-camera. The one photograph Fenton took in the Crimea that

reaches beyond benign documentation is "The Valley of the Shadow of Death," whose title evokes the consolation offered by the biblical psalmist as well as the disaster of the previous October in which six hundred British soldiers were ambushed on the plain above Balaklava—Tennyson called the site "the valley of Death" in his memorial poem "The Charge of the Light Brigade." Fenton's memorial photograph is a portrait of absence, of death without the dead. It is the only photograph he took that would not have needed to be staged, for all it shows is a wide rutted road studded with rocks and cannonballs that curves onward across a barren rolling plain to the distant void.

A bolder portfolio of after-the-battle images of death and ruin, pointing not to losses suffered but to a fearsome exaction of British military might, was made by another photographer who had visited the Crimean War. Felice Beato, a naturalized Englishman (he was born in Venice), was the first photographer to attend a number of wars: besides being in the Crimea in 1855, he was at the Sepoy Rebellion (what the

British call the Indian Mutiny) in 1857–58, the Second Opium War in China in 1860, and the Sudanese colonial wars in 1885. Three years after Fenton made his an- odyne images of a war that did not go well for England, Beato was celebrating the fierce victory of the British army over a mutiny of native soldiers under its command, the first important challenge to British rule in India. The arresting photograph Beato took in Lucknow of the Sikandarbagh Palace, gut- ted by the British bombardment, shows the courtyard strewn with rebels' bones.

The first full-scale attempt to document a war was carried out a few years later, during the American Civil War, by a firm of Northern photographers headed by Mathew Brady, who had made several official portraits of President Lincoln. The Brady war pictures—most were taken by Alexander Gardner and Timothy O'Sullivan, though their employer was invariably credited with them—showed conventional subjects such as encampments populated by officers and foot soldiers, towns in war's way, ordnance, ships, as well as, most

famously, dead Union and Confederate sol-
diers lying on the blasted ground of
Gettysburg and Antietam. Though access to
the battlefield came as a privilege extended
to Brady and his team by Lincoln himself,
the photographers were not commis-
sioned as Fenton had been. Their status
evolved in a more American fashion, with
nominal government sponsorship giving
way to the force of entrepreneurial and free-
lance motives.

The first justification for the brutally leg-
ible pictures of dead soldiers, which clearly
violated a taboo, was the simple duty to
record. "The camera is the eye of history,"
Brady is supposed to have said. And history,
invoked as a truth beyond appeal, was
allied with the rising prestige of a certain
idea of subjects needing further attention
known as realism—soon to have more
defenders among novelists than among
photographers.[5] In the name of realism,

5. The deflating realism of the photographs of slain
soldiers lying about the battlefield is dramatized in
The Red Badge of Courage, in which everything is

one was permitted—required—to show unpleasant, hard facts. Such pictures also convey "a useful moral" by showing "the blank horror and reality of war, in opposition to its pageantry," Gardner wrote in the text accompanying O'Sullivan's picture of fallen Confederate soldiers, their agonized faces turned to the viewer, in the album of pictures by him and other Brady photographers that he published after the war. (Gardner left Brady's employ in 1863.)

seen through the bewildered, terrified consciousness of someone who could well have been one of those soldiers. Stephen Crane's piercingly visual, mono-voiced antiwar novel—which appeared in 1895, thirty years after the war ended (Crane was born in 1871)—is a long, simplifying emotional distance from Walt Whitman's contemporary, multiform treatment of war's "red business." In *Drum-Taps*, the poem cycle Whitman published in 1865 (and later folded into *Leaves of Grass*), many voices are summoned to speak. Though far from enthusiastic about this war, which he identified with fratricide, and for all his sorrow over the suffering on both sides, Whitman could not help but hear war's epic and heroic music. His ear kept him martial, albeit in his own generous, complex, amatory way.

"Here are the dreadful details! Let them aid in preventing such another calamity from falling upon the nation." But the frankness of the most memorable pictures in *Gardner's Photographic Sketch Book of the War* (1866) did not mean that he and his colleagues had necessarily photographed their subjects as they found them. To photograph was to compose (with living subjects, to pose), and the desire to arrange elements in the picture did not vanish because the subject was immobilized, or immobile.

Not surprisingly, many of the canonical images of early war photography turn out to have been staged, or to have had their subjects tampered with. After reaching the much-shelled valley approaching Sebastopol in his horse-drawn darkroom, Fenton made two exposures from the same tripod position: in the first version of the celebrated photograph he was to call "The Valley of the Shadow of Death" (despite the title, it was *not* across this landscape that the Light Brigade made its doomed charge), the cannonballs are thick on the ground to the left of the road, but before taking the second picture—

the one that is always reproduced—he over-saw the scattering of cannonballs on the road itself. A picture of a desolate site where a great deal of dying had indeed taken place, Beato's image of the devastated Sikandar-bagh Palace involved a more thorough ar-rangement of its subject, and was one of the first photographic depictions of the horrific in war. The attack had taken place in No-vember 1857, after which the victorious British troops and loyal Indian units searched the palace room by room, bayoneting the eighteen hundred surviving Sepoy defenders who were now their prisoners and throwing their bodies into the courtyard; vultures and dogs did the rest. For the photograph he took in March or April 1858, Beato con-structed the ruin as an unburial ground, stationing some natives by two pillars in the rear and distributing human bones about the courtyard.

At least they were old bones. It's now known that the Brady team rearranged and displaced some of the recently dead at Gettysburg: the picture titled "The Home of a Rebel Sharpshooter, Gettysburg" shows

in fact a dead Confederate soldier who was moved from where he had fallen on the field to a more photogenic site, a cove formed by several boulders flanking a barricade of rocks, and includes a prop rifle that Gardner leaned against the barricade beside the corpse. (It seems not to have been the special rifle a sharpshooter would have used, but a common infantryman's rifle; Gardner didn't know this or didn't care.) What is odd is not that so many of the iconic news photos of the past, including some of the best-remembered pictures from the Second World War, appear to have been staged. It is that we are surprised to learn they were staged, and always disappointed.

The photographs we are particularly dismayed to find out have been posed are those that appear to record intimate climaxes, above all, of love and death. The point of "The Death of a Republican Soldier" is that it is a real moment, captured fortuitously; it loses all value should the falling soldier turn out to have been performing for Capa's camera. Robert Doisneau never explicitly claimed snapshot status for

a photograph taken in 1950 for *Life* of a young couple kissing on the sidewalk near Paris's Hôtel de Ville. Still, the revelation more than forty years later that the picture was a directorial setup with a woman and a man hired for the day to smooch for Doisneau provoked many a spasm of chagrin among those for whom it is a cherished vision of romantic love and romantic Paris. We want the photographer to be a spy in the house of love and of death, and those being photographed to be unaware of the camera, "off guard." No sophisticated sense of what photography is or can be will ever weaken the satisfactions of a picture of an unexpected event seized in mid-action by an alert photographer.

If we admit as authentic only photographs that result from the photographer's having been nearby, shutter open, at just the right moment, few victory photographs will qualify. Take the action of planting a flag on a height as a battle is winding down. The famous photograph of the raising of the American flag on Iwo Jima on February 23, 1945, turns out to be a "reconstruction" by

an Associated Press photographer, Joe Rosenthal, of the morning flag-raising ceremony that followed the capture of Mount Suribachi, done later in the day and with a larger flag. The story behind an equally iconic victory photograph, taken on May 2, 1945, by the Soviet war photographer Yevgeny Khaldei, of Russian soldiers hoisting the Red flag atop the Reichstag as Berlin continues to burn, is that the exploit was staged for the camera. The case of a much-reproduced upbeat photograph taken in London in 1940, during the Blitz, is more complicated, since the photographer, and therefore the circumstances of the picture-taking, are unknown. The picture shows, through a missing wall of the utterly ruined, roofless library of Holland House, three gentlemen standing in the rubble at some distance from one another before two walls of miraculously intact bookshelves. One gazes at the books; one hooks his finger on the spine of a book he is about to pull from the shelf; one, book in hand, is reading—the elegantly composed tableau has to have been directed. It is pleasing to imagine that the

picture is not the invention from scratch of a photographer on the prowl in Kensington after an air raid who, discovering the library of the great Jacobean mansion sheared open to view, had brought in three men to play the imperturbable browsers, but, rather, that the three gents were observed indulging their bookish appetites in the destroyed mansion and the photographer did little more than space them differently to make a more incisive picture. Either way, the photograph retains its period charm and authenticity as a celebration of a now vanished ideal of national fortitude and sangfroid. With time, many staged photographs turn back into historical evidence, albeit of an impure kind—like most historical evidence.

Only starting with the Vietnam War is it virtually certain that none of the best-known photographs were setups. And this is essential to the moral authority of these images. The signature Vietnam War horror-photograph from 1972, taken by Huynh Cong Ut, of children from a village that has just been doused with American napalm, running down the highway, shrieking with

pain, belongs to the realm of photographs that cannot possibly be posed. The same is true of the well-known pictures from the most photographed wars since. That there have been so few staged war photographs since the Vietnam War suggests that photographers are being held to a higher standard of journalistic probity. One part of the explanation for this may be that in Vietnam television became the defining medium for showing images of war, and the intrepid lone photographer with Leica or Nikon in hand, operating out of sight much of the time, now had to compete with and endure the proximity of TV crews: the witnessing of war is now hardly ever a solitary venture. Technically, the possibilities for doctoring or electronically manipulating pictures are greater than ever—almost unlimited. But the practice of inventing dramatic news pictures, staging them for the camera, seems on its way to becoming a lost art.

4

TO CATCH A DEATH actually happening and embalm it for all time is something only cameras can do, and pictures taken by photographers out in the field of the moment of (or just before) death are among the most celebrated and often reproduced of war photographs. There can be no suspicion about the authenticity of what is being shown in the picture taken by Eddie Adams in February 1968 of the chief of the South Vietnamese national police, Brigadier General Nguyen Ngoc Loan, shooting a Vietcong suspect in a street in Saigon. Nevertheless, it was staged—by General Loan, who had led the prisoner, hands tied behind his back, out to the street where journalists had gathered; he would not have carried out the summary execution there had they not been available to witness it. Positioned beside his prisoner so that his profile and the prisoner's face were visible to

the cameras behind him, Loan aimed point-blank. Adams's picture shows the moment the bullet has been fired; the dead man, grimacing, has not started to fall. As for the viewer, this viewer, even many years after the picture was taken ... well, one can gaze at these faces for a long time and not come to the end of the mystery, and the indecency, of such co-spectatorship.

More upsetting is the opportunity to look at people who know they have been condemned to die: the cache of six thousand photographs taken between 1975 and 1979 at a secret prison in a former high school in Tuol Sleng, a suburb of Phnom Penh, the killing house of more than fourteen thousand Cambodians charged with being either "intellectuals" or "counter-revolutionaries"—the documentation of this atrocity courtesy of the Khmer Rouge record keepers, who had each sit for a photograph just before being executed.[6] A

6. Photographing political prisoners and alleged counter-revolutionaries just before their execution was also standard practice in the Soviet Union in

selection of these pictures in a book titled *The Killing Fields* makes it possible, decades later, to stare back at the faces staring into the camera—therefore at us. The Spanish Republican soldier has just died, if we may believe the claim made for that picture, which Capa took at some distance from his subject: we see no more than a grainy figure, a body and head, an energy, swerving from the camera as he falls. These Cambodian women and men of all ages, including many children, photographed from a few feet away, usually in half figure, are—as in Titian's *The Flaying of Marsyas*, where Apollo's knife is eternally about to descend—forever looking at death, forever about to be murdered, forever wronged. And the viewer is in the same position as the lackey behind the camera; the experience is sickening. The prison photographer's name is known—Nhem Ein—and can be cited. Those he photographed, with

the 1930s and 1940s, as recent research into the NKVD files in the Baltic and Ukrainian archives, as well as the central Lubyanka archives, has disclosed.

their stunned faces, their emaciated torsos, the number tags pinned to the top of their shirts, remain an aggregate: anonymous victims.

And even if named, unlikely to be known to "us." When Woolf notes that one of the photographs she has been sent shows a corpse of a man or woman so mangled that it could as well be that of a dead pig, her point is that the scale of war's murderousness destroys what identifies people as individuals, even as human beings. This, of course, is how war looks when it is seen from afar, as an image.

Victims, grieving relatives, consumers of news—all have their own nearness to or distance from war. The frankest representations of war, and of disaster-injured bodies, are of those who seem most foreign, therefore least likely to be known. With subjects closer to home, the photographer is expected to be more discreet.

When, in October 1862, a month after the battle of Antietam, photographs taken by Gardner and O'Sullivan were exhibited

at Brady's Manhattan gallery, *The New York Times* commented:

> The living that throng Broadway care little perhaps for the Dead at Antietam, but we fancy they would jostle less carelessly down the great thoroughfare, saunter less at their ease, were a few dripping bodies, fresh from the field, laid along the pavement. There would be a gathering up of skirts and a careful picking of way . . .

Concurring in the perennial charge that those whom war spares are callously indifferent to the sufferings beyond their purview did not make the reporter less ambivalent about the immediacy of the photograph.

> The dead of the battlefield come to us very rarely even in dreams. We see the list in the morning paper at breakfast but dismiss its recollection with the coffee. But Mr. Brady has done

something to bring home to us the terrible reality and earnestness of war. If he has not brought bodies and laid them in our dooryards and along the streets, he has done something very like it . . . These pictures have a terrible distinctness. By the aid of the magnifying-glass, the very features of the slain may be distinguished. We would scarce choose to be in the gallery, when one of the women bending over them should recognize a husband, a son, or a brother in the still, lifeless lines of bodies, that lie ready for the gaping trenches.

Admiration is mixed with disapproval of the pictures for the pain they might give the female relatives of the dead. The camera brings the viewer close, too close; supplemented by a magnifying glass—for this is a double-lens story—the "terrible distinctness" of the pictures gives unnecessary, indecent information. Yet the *Times* reporter cannot resist the melodrama that mere words supply (the "dripping bodies"

ready for "the gaping trenches"), while reprehending the intolerable realism of the image.

New demands are made on reality in the era of cameras. The real thing may not be fearsome enough, and therefore needs to be enhanced; or reenacted more convincingly. Thus, the first newsreel ever made of a battle—a much-publicized incident in Cuba during the Spanish-American War of 1898 known as the Battle of San Juan Hill—in fact shows a charge staged shortly afterward by Colonel Theodore Roosevelt and his volunteer cavalry unit, the Rough Riders, for the Vitagraph cameramen, the actual charge up the hill, after it was filmed, having been judged insufficiently dramatic. Or the images may be too terrible, and need to be suppressed in the name of propriety or of patriotism—like the images showing, without appropriate partial concealment, our dead. To display the dead, after all, is what the enemy does. In the Boer War (1899–1902), after their victory at Spion Kop in January 1900, the Boers thought it would be morale-building for their own troops to circulate a horrifying picture of

dead British soldiers. Taken by an unknown Boer photographer ten days after the British defeat, which had cost the lives of thirteen hundred of their soldiers, it gives an intrusive view down a long shallow trench packed with unburied bodies. What is particularly aggressive about the image is the absence of a landscape. The trench's receding jumble of bodies fills the whole picture space. British indignation upon hearing of this latest Boer outrage was keen, if stiffly expressed: to have made public such pictures, declared *Amateur Photographer*, "serves no useful purpose and appeals to the morbid side of human nature solely."

There had always been censorship, but for a long time it remained desultory, at the pleasure of generals and heads of state. The first organized ban on press photography at the front came during the First World War; both the German and French high commands allowed only a few selected military photographers near the fighting. (Censorship of the press by the British General Staff was less inflexible.) And it took another fifty years, and the relaxation of

censorship with the first televised war coverage, to understand what impact shocking photographs could have on the domestic public. During the Vietnam era, war photography became, normatively, a criticism of war. This was bound to have consequences: mainstream media are not in the business of making people feel queasy about the struggles for which they are being mobilized, much less of disseminating propaganda against waging war.

Since then, censorship—the most extensive kind, self-censorship, as well as censorship imposed by the military—has found a large and influential number of apologists. At the start of the British campaign in the Falklands in April 1982, the government of Margaret Thatcher granted access to only two photojournalists— among those refused was a master war photographer, Don McCullin—and only three batches of film reached London before the islands were recaptured in May. No direct television transmission was permitted. There had not been such drastic restrictions on the reporting of a British

military operation since the Crimean War. It proved harder for the American authorities to duplicate the Thatcher controls on the reporting of their own foreign adventures. What the American military promoted during the Gulf War in 1991 were images of the techno war: the sky above the dying, filled with light-traces of missiles and shells—images that illustrated America's absolute military superiority over its enemy. American television viewers weren't allowed to see footage acquired by NBC (which the network then declined to run) of what that superiority could wreak: the fate of thousands of Iraqi conscripts who, having fled Kuwait City at the end of the war, on February 27, were carpet bombed with explosives, napalm, radioactive DU (depleted uranium) rounds, and cluster bombs as they headed north, in convoys and on foot, on the road to Basra, Iraq—a slaughter notoriously described by one American officer as a "turkey shoot." And most American operations in Afghanistan in late 2001 were off-limits to news photographers.

The terms for allowing the use of cameras at the front for nonmilitary purposes have become much stricter as war has become an activity prosecuted with increasingly exact optical devices for tracking the enemy. There is no war without photography, that notable aesthete of war Ernst Jünger observed in 1930, thereby refining the irrepressible identification of the camera and the gun, "shooting" a subject and shooting a human being. War-making and picture-taking are congruent activities: "It is the same intelligence, whose weapons of annihilation can locate the enemy to the exact second and meter," wrote Jünger, "that labors to preserve the great historical event in fine detail."[7]

7. Thus, thirteen years before the destruction of Guernica, Arthur Harris, later the chief of Bombing Command in the Royal Air Force during the Second World War, then a young RAF squadron leader in Iraq, described the air campaign to crush the rebellious natives in this newly acquired British colony, complete with photographic proof of the success of the mission. "The Arab and the Kurd," he wrote in 1924, "now know what real bombing means

The preferred current American way of war-making has expanded on this model. Television, whose access to the scene is limited by government controls and by self-censorship, serves up the war as images. The war itself is waged as much as possible at a distance, through bombing, whose targets can be chosen, on the basis of instantly relayed information and visualizing technology, from continents away: the daily bombing operations in Afghanistan in late 2001 and early 2002 were directed from U.S. Central Command in Tampa, Florida. The aim is to produce a sufficiently punishing number of casualties on the other side while minimizing opportunities for the enemy to inflict any casualties at all; American and allied soldiers who die in vehicle accidents or from "friendly fire"

in casualties and damage; they now know that within forty-five minutes a full-sized village (vide attached photos of Kushan-Al-Ajaza) can be practically wiped out and a third of its inhabitants killed by four or five machines which offer them no real target, no opportunity for glory as warriors, no effective means of escape."

(as the euphemism has it) both count and don't count.

In the era of tele-controlled warfare against innumerable enemies of American power, policies about what is to be seen and not seen by the public are still being worked out. Television news producers and newspaper and magazine photo editors make decisions every day which firm up the wavering consensus about the boundaries of public knowledge. Often their decisions are cast as judgments about "good taste"—always a repressive standard when invoked by institutions. Staying within the bounds of good taste was the primary reason given for not showing any of the horrific pictures of the dead taken at the site of the World Trade Center in the immediate aftermath of the attack on September 11, 2001. (Tabloids are usually bolder than broadsheet papers in printing grisly images; a picture of a severed hand lying in the rubble of the World Trade Center ran in one late edition of New York's *Daily News* shortly after the attack; it seems not to have appeared in any other paper.) And

television news, with its much larger audience and therefore greater responsiveness to pressures from advertisers, operates under even stricter, for the most part self-policed constraints on what is "proper" to air. This novel insistence on good taste in a culture saturated with commercial incentives to lower standards of taste may be puzzling. But it makes sense if understood as obscuring a host of concerns and anxieties about public order and public morale that cannot be named, as well as pointing to the inability otherwise to formulate or defend traditional conventions of how to mourn. What can be shown, what should not be shown—few issues arouse more public clamor.

The other argument often used to suppress pictures cites the rights of relatives. When a weekly newspaper in Boston briefly posted online a propaganda video made in Pakistan that showed the "confession" (that he was Jewish) and subsequent ritual slaughter of the kidnapped American journalist Daniel Pearl in Karachi in early 2002, a vehement debate took place in

which the right of Pearl's widow to be spared more pain was pitted against the newspaper's right to print and post what it saw fit and the public's right to see. The video was quickly taken offline. Notably, both sides treated the three and a half minutes of horror only as a snuff film. Nobody could have learned from the debate that the video had other footage, a montage of stock accusations (for instance, images of Ariel Sharon sitting with George W. Bush at the White House, Palestinian children killed in Israeli attacks), that it was a political diatribe and ended with dire threats and a list of specific demands—all of which might suggest that it was worth suffering through (if you could bear it) to confront better the particular viciousness and intransigence of the forces that murdered Pearl. It is easier to think of the enemy as just a savage who kills, then holds up the head of his prey for all to see.

With our dead, there has always been a powerful interdiction against showing the naked face. The photographs taken by Gardner and O'Sullivan still shock because the Union and Confederate soldiers lie on

their backs, with the faces of some clearly visible. American soldiers fallen on the battlefield were not shown again in a major publication for many wars, not, indeed, until the taboo-shattering picture by George Strock that *Life* published in September 1943—it had initially been withheld by the military censors—of three soldiers killed on the beach during a landing in New Guinea. (Though "Dead GIs on Buna Beach" is invariably described as showing three soldiers lying face down in the wet sand, one of the three lies on his back, but the angle from which the picture was taken conceals his head.) By the time of the landing in France—June 6, 1944—photographs of anonymous American casualties had appeared in a number of newsmagazines, always prone or shrouded or with their faces turned away. This is a dignity not thought necessary to accord to others.

The more remote or exotic the place, the more likely we are to have full frontal views of the dead and dying. Thus postcolonial Africa exists in the consciousness of the

general public in the rich world—besides through its sexy music—mainly as a succession of unforgettable photographs of large-eyed victims, starting with figures in the famine lands of Biafra in the late 1960s to the survivors of the genocide of nearly a million Rwandan Tutsis in 1994 and, a few years later, the children and adults whose limbs were hacked off during the program of mass terror conducted by the RUF, the rebel forces in Sierra Leone. (More recently, the photographs are of whole families of indigent villagers dying of AIDS.) These sights carry a double message. They show a suffering that is outrageous, unjust, and should be repaired. They confirm that this is the sort of thing which happens in that place. The ubiquity of those photographs, and those horrors, cannot help but nourish belief in the inevitability of tragedy in the benighted or backward—that is, poor—parts of the world.

Comparable cruelties and misfortunes used to take place in Europe, too; cruelties that surpass in volume and luridness anything we might be shown now from the

poor parts of the world occurred in Europe only sixty years ago. But horror seems to have vacated Europe, vacated it for long enough to make the present pacified state of affairs seem inevitable. (That there could be death camps and a siege and civilians slaughtered by the thousands and thrown into mass graves on European soil fifty years after the end of the Second World War gave the war in Bosnia and the Serb campaign of killing in Kosovo their special, anachronistic interest. But one of the main ways of understanding the war crimes committed in southeastern Europe in the 1990s has been to say that the Balkans, after all, were never really part of Europe.) Generally, the grievously injured bodies shown in published photographs are from Asia or Africa. This journalistic custom inherits the centuries-old practice of exhibiting exotic—that is, colonized—human beings: Africans and denizens of remote Asian countries were displayed like zoo animals in ethnological exhibitions mounted in London, Paris, and other European capitals from the sixteenth until the early twentieth century. In *The*

Tempest, Trinculo's first thought upon coming across Caliban is that he could be put on exhibit in England: "not a holiday fool there but would give a piece of silver . . . When they will not give a doit to relieve a lame beggar, they will lay out ten to see a dead Indian." The exhibition in photographs of cruelties inflicted on those with darker complexions in exotic countries continues this offering, oblivious to the considerations that deter such displays of our own victims of violence; for the other, even when not an enemy, is regarded only as someone to be seen, not someone (like us) who also sees. But surely the wounded Taliban soldier begging for his life whose fate was pictured prominently in *The New York Times* also had a wife, children, parents, sisters, and brothers, some of whom may one day come across the three color photographs of their husband, father, son, brother being slaughtered—if they have not already seen them.

5

CENTRAL TO MODERN EXPECTATIONS, and modern ethical feeling, is the conviction that war is an aberration, if an unstoppable one. That peace is the norm, if an unattainable one. This, of course, is not the way war has been regarded throughout history. War has been the norm and peace the exception.

The description of the exact fashion in which bodies are injured and killed in combat is a recurring climax in the stories told in the *Iliad*. War is seen as something men do inveterately, undeterred by the accumulation of the suffering it inflicts; and to represent war in words or in pictures requires a keen, unflinching detachment. When Leonardo da Vinci gives instructions for a battle painting, he insists that artists have the courage and the imagination to show war in all its ghastliness:

Make the conquered and beaten pale, with brows raised and knit, and the skin above their brows furrowed with pain ... and the teeth apart as with crying out in lamentation ... Make the dead partly or entirely covered with dust ... and let the blood be seen by its color flowing in a sinuous stream from the corpse to the dust. Others in the death agony grinding their teeth, rolling their eyes, with their fists clenched against their bodies, and the legs distorted.

The concern is that the images to be devised won't be sufficiently upsetting: not concrete, not detailed enough. Pity can entail a moral judgment if, as Aristotle maintains, pity is considered to be the emotion that we owe only to those enduring undeserved misfortune. But pity, far from being the natural twin of fear in the dramas of catastrophic misfortune, seems diluted—distracted—by fear, while fear (dread, terror) usually manages to swamp pity. Leonardo is suggesting that the artist's

gaze be, literally, pitiless. The image should appall, and in that *terribilità* lies a challenging kind of beauty.

That a gory battlescape could be beautiful—in the sublime or awesome or tragic register of the beautiful—is a commonplace about images of war made by artists. The idea does not sit well when applied to images taken by cameras: to find beauty in war photographs seems heartless. But the landscape of devastation is still a landscape. There is beauty in ruins. To acknowledge the beauty of photographs of the World Trade Center ruins in the months following the attack seemed frivolous, sacrilegious. The most people dared say was that the photographs were "surreal," a hectic euphemism behind which the disgraced notion of beauty cowered. But they were beautiful, many of them—by veteran photographers such as Gilles Peress, Susan Meiselas, and Joel Meyerowitz, among others. The site itself, the mass graveyard that had received the name "Ground Zero," was of course anything but beautiful. Photographs tend to

transform, whatever their subject; and as an image something may be beautiful—or terrifying, or unbearable, or quite bearable— as it is not in real life.

Transforming is what art does, but photography that bears witness to the calamitous and the reprehensible is much criticized if it seems "aesthetic"; that is, too much like art. The dual powers of photography— to generate documents and to create works of visual art—have produced some remarkable exaggerations about what photographers ought or ought not to do. Lately, the most common exaggeration is one that regards these powers as opposites. Photographs that depict suffering shouldn't be beautiful, as captions shouldn't moralize. In this view, a beautiful photograph drains attention from the sobering subject and turns it toward the medium itself, thereby compromising the picture's status as a document. The photograph gives mixed signals. Stop this, it urges. But it also exclaims, What a spectacle![8]

8. The photographs of Bergen-Belsen, Buchen-

Take one of the most poignant images from the First World War: a line of English soldiers blinded by poison gas—each rests his hand on the left shoulder of the man ahead of him—shuffling toward a dressing station. It could be an image from one of the searing movies made about the war—King Vidor's *The Big Parade* (1925) or G. W. Pabst's *Westfront 1918*, Lewis Milestone's *All Quiet on the Western Front*, or Howard Hawks's *The Dawn Patrol* (all from 1930). That war photography seems, retroactively, to be echoing as much as inspiring the reconstruction of battle scenes in impor-

wald, and Dachau taken in April and May 1945 by anonymous witnesses and military photographers seem more valid than the "better" professional images taken by two celebrated professionals, Margaret Bourke-White and Lee Miller. But the criticism of the professional look in war photography is not a recent view. Walker Evans, for example, detested the work of Bourke-White. But then Evans, who photographed poor American peasants for a book with the heavily ironic title *Let Us Now Praise Famous Men*, would never take a picture of anybody famous.

tant war movies has begun to backfire on the photographer's enterprise. What assured the authenticity of Steven Spielberg's acclaimed re-creation of the Omaha Beach landing on D-Day in *Saving Private Ryan* (1998) was that it was based, among other sources, on the photographs taken with immense bravery by Robert Capa during the landing. But a war photograph seems inauthentic, even though there is nothing staged about it, when it looks like a still from a movie. A photographer who specializes in world misery (including but not restricted to the effects of war), Sebastião Salgado, has been the principal target of the new campaign against the inauthenticity of the beautiful. Particularly with the seven-year project he calls "Migrations: Humanity in Transition," Salgado has come under steady attack for producing spectacular, beautifully composed big pictures that are said to be "cinematic."

The sanctimonious Family of Man–style rhetoric that feathers Salgado's exhibitions and books has worked to the

detriment of the pictures, however unfair this may be. (There is much humbug to be found, and ignored, in declarations made by some of the most admirable photographers of conscience.) Salgado's pictures have also been sourly treated in response to the commercialized situations in which, typically, his portraits of misery are seen. But the problem is in the pictures themselves, not how and where they are exhibited: in their focus on the powerless, reduced to their powerlessness. It is significant that the powerless are not named in the captions. A portrait that declines to name its subject becomes complicit, if inadvertently, in the cult of celebrity that has fueled an insatiable appetite for the opposite sort of photograph: to grant only the famous their names demotes the rest to representative instances of their occupations, their ethnicities, their plights. Taken in thirty-nine countries, Salgado's migration pictures group together, under this single heading, a host of different causes and kinds of distress. Making suffering loom larger, by globalizing it, may spur people to feel they ought

to "care" more. It also invites them to feel that the sufferings and misfortunes are too vast, too irrevocable, too epic to be much changed by any local political intervention. With a subject conceived on this scale, compassion can only flounder—and make abstract. But all politics, like all of history, is concrete. (To be sure, nobody who really thinks about history can take politics altogether seriously.)

It used to be thought, when the candid images were not common, that showing something that needed to be seen, bringing a painful reality closer, was bound to goad viewers to feel more. In a world in which photography is brilliantly at the service of consumerist manipulations, no effect of a photograph of a doleful scene can be taken for granted. As a consequence, morally alert photographers and ideologues of photography have become increasingly concerned with the issues of exploitation of sentiment (pity, compassion, indignation) in war photography and of rote ways of provoking feeling.

Photographer-witnesses may think it

more correct morally to make the spectac-
ular not spectacular. But the spectacular is
very much part of the religious narratives by
which suffering, throughout most of West-
ern history, has been understood. To feel
the pulse of Christian iconography in cer-
tain wartime or disaster-time photographs
is not a sentimental projection. It would
be hard not to discern the lineaments of the
Pietà in W. Eugene Smith's picture of a
woman in Minamata cradling her de-
formed, blind, and deaf daughter, or the
template of the Descent from the Cross in
several of Don McCullin's pictures of dying
American soldiers in Vietnam. However,
such perceptions—which add aura and
beauty—may be on the wane. The German
historian Barbara Duden has said that
when she was teaching a course in the his-
tory of representations of the body at a large
American state university some years ago,
not one student in a class of twenty under-
graduates could identify the subject of any
of the canonical paintings of the Flagella-
tion she showed as slides. ("I think it's a re-
ligious picture," one ventured.) The only

canonical image of Jesus she could count on most students being able to identify was the Crucifixion.

Photographs objectify: they turn an event or a person into something that can be possessed. And photographs are a species of alchemy, for all that they are prized as a transparent account of reality.

Often something looks, or is felt to look, "better" in a photograph. Indeed, it is one of the functions of photography to improve the normal appearance of things. (Hence, one is always disappointed by a photograph that is not flattering.) Beautifying is one classic operation of the camera, and it tends to bleach out a moral response to what is shown. Uglifying, showing something at its worst, is a more modern function: didactic, it invites an active response. For photographs to accuse, and possibly to alter conduct, they must shock.

An example: A few years ago, the public

health authorities in Canada, where it had been estimated that smoking kills forty-five thousand people a year, decided to supplement the warning printed on every pack of cigarettes with a shock-photograph—of cancerous lungs, or a stroke-clotted brain, or a damaged heart, or a bloody mouth in acute periodontal distress. A pack with such a picture accompanying the warning about the deleterious effects of smoking would be sixty times more likely to inspire smokers to quit, a research study had somehow calculated, than a pack with only the verbal warning.

Let's assume this is true. But one might wonder, for how long? Does shock have term limits? Right now the smokers of Canada are recoiling in disgust, if they do look at these pictures. Will those still smoking five years from now still be upset? Shock can become familiar. Shock can wear off. Even if it doesn't, one can *not* look. People have means to defend themselves against what is upsetting—in this instance, unpleasant information for those wishing to continue to smoke. This seems normal, that is, adaptive.

As one can become habituated to horror in real life, one can become habituated to the horror of certain images.

Yet there are cases where repeated exposure to what shocks, saddens, appalls does not use up a full-hearted response. Habituation is not automatic, for images (portable, insertable) obey different rules than real life. Representations of the Crucifixion do not become banal to believers, if they really are believers. This is even more true of staged representations. Performances of *Chushingura*, probably the best-known narrative in all of Japanese culture, can be counted on to make a Japanese audience sob when Lord Asano admires the beauty of the cherry blossoms on his way to where he must commit seppuku—sob each time, no matter how often they have followed the story (as a Kabuki or Bunraku play, as a film); the *ta'ziyah* drama of the betrayal and murder of Imam Hussayn does not cease to bring an Iranian audience to tears no matter how many times they have seen the martyrdom enacted. On the contrary. They weep, in part, because they have seen it many

times. People want to weep. Pathos, in the
form of a narrative, does not wear out.

But do people want to be horrified?
Probably not. Still, there are pictures whose
power does not abate, in part because one
cannot look at them often. Pictures of the
ruin of faces that will always testify to a
great iniquity survived, at that cost: the
faces of horribly disfigured First World War
veterans who survived the inferno of the
trenches; the faces melted and thickened
with scar tissue of survivors of the Ameri-
can atomic bombs dropped on Hiroshima
and Nagasaki; the faces cleft by machete
blows of Tutsi survivors of the geno-
cidal rampage launched by the Hutus in
Rwanda—is it correct to say that people get
used to these?

Indeed, the very notion of atrocity, of war
crime, is associated with the expectation of
photographic evidence. Such evidence is,
usually, of something posthumous; the re-
mains, as it were—the mounds of skulls in
Pol Pot's Cambodia, the mass graves in
Guatemala and El Salvador, Bosnia and
Kosovo. And this posthumous reality is

often the keenest of summations. As Hannah Arendt pointed out soon after the end of the Second World War, all the photographs and newsreels of the concentration camps are misleading because they show the camps at the moment the Allied troops marched in. What makes the images unbearable—the piles of corpses, the skeletal survivors—was not at all typical for the camps, which, when they were functioning, exterminated their inmates systematically (by gas, not starvation and illness), then immediately cremated them. And photographs echo photographs: it was inevitable that the photographs of emaciated Bosnian prisoners at Omarska, the Serb death camp created in northern Bosnia in 1992, would recall the photographs taken in the Nazi death camps in 1945.

Photographs of atrocity illustrate as well as corroborate. Bypassing disputes about exactly how many were killed (numbers are often inflated at first), the photograph gives the indelible sample. The illustrative function of photographs leaves opinions, prejudices, fantasies, misinformation un-

touched. The information that many fewer Palestinians died in the assault on Jenin than had been claimed by Palestinian officials (as the Israelis had said all along) made much less impact than the photographs of the razed center of the refugee camp. And, of course, atrocities that are not secured in our minds by well-known photographic images, or of which we simply have had very few images—the total extermination of the Herero people in Namibia decreed by the German colonial administration in 1904; the Japanese onslaught in China, notably the massacre of nearly four hundred thousand, and the rape of eighty thousand, Chinese in December 1937, the so-called Rape of Nanking; the rape of some one hundred and thirty thousand women and girls (ten thousand of whom committed suicide) by victorious Soviet soldiers unleashed by their commanding officers in Berlin in 1945—seem more remote. These are memories that few have cared to claim.

The familiarity of certain photographs builds our sense of the present and immediate past. Photographs lay down routes of

reference, and serve as totems of causes: sentiment is more likely to crystallize around a photograph than around a verbal slogan. And photographs help construct— and revise—our sense of a more distant past, with the posthumous shocks engineered by the circulation of hitherto unknown photographs. Photographs that everyone recognizes are now a constituent part of what a society chooses to think about, or declares that it has chosen to think about. It calls these ideas "memories," and that is, over the long run, a fiction. Strictly speaking, there is no such thing as collective memory—part of the same family of spurious notions as collective guilt. But there is collective instruction.

All memory is individual, unreproducible—it dies with each person. What is called collective memory is not a remembering but a stipulating: that *this* is important, and this is the story about how it happened, with the pictures that lock the story in our minds. Ideologies create substantiating archives of images, representative images, which encapsulate common ideas of signifi-

cance and trigger predictable thoughts, feelings. Poster-ready photographs—the mushroom cloud of an A-bomb test, Martin Luther King, Jr., speaking at the Lincoln Memorial in Washington, D.C., the astronaut walking on the moon—are the visual equivalent of sound bites. They commemorate, in no less blunt fashion than postage stamps, Important Historical Moments; indeed, the triumphalist ones (the picture of the A-bomb excepted) become postage stamps. Fortunately, there is no one signature picture of the Nazi death camps.

As art has been redefined during a century of modernism as whatever is destined to be enshrined in some kind of museum, so it is now the destiny of many photographic troves to be exhibited and preserved in museum-like institutions. Among such archives of horror, the photographs of genocide have undergone the greatest institutional development. The point of creating public repositories for these and other relics is to ensure that the crimes they depict will continue to figure in people's consciousness.

This is called remembering, but in fact it is a good deal more than that.

The memory museum in its current pro-liferation is a product of a way of thinking about, and mourning, the destruction of European Jewry in the 1930s and 1940s, which came to institutional fruition in Yad Vashem in Jerusalem, the Holocaust Me-morial Museum in Washington, D.C., and the Jewish Museum in Berlin. Photographs and other memorabilia of the Shoah have been committed to a perpetual recircula-tion, to ensure that what they show will be remembered. Photographs of the suffering and martyrdom of a people are more than reminders of death, of failure, of victimiza-tion. They invoke the miracle of survival. To aim at the perpetuation of memories means, inevitably, that one has undertaken the task of continually renewing, of creating, memories—aided, above all, by the impress of iconic photographs. People want to be able to visit—and refresh—their memories. Now many victim peoples want a memory museum, a temple that houses a comprehen-sive, chronologically organized, illustrated

narrative of their sufferings. Armenians, for example, have long been clamoring for a museum in Washington to institutionalize the memory of the genocide of Armenian people by the Ottoman Turks. But why is there not already, in the nation's capital, which happens to be a city whose population is overwhelmingly African-American, a Museum of the History of Slavery? Indeed, there is no Museum of the History of Slavery—the whole story, starting with the slave trade in Africa itself, not just selected parts, such as the Underground Railroad—anywhere in the United States. This, it seems, is a memory judged too dangerous to social stability to activate and to create. The Holocaust Memorial Museum and the future Armenian Genocide Museum and Memorial are about what didn't happen in America, so the memory-work doesn't risk arousing an embittered domestic population against authority. To have a museum chronicling the great crime that was African slavery in the United States of America would be to acknowledge that the evil was *here*. Americans prefer to picture the

evil that was *there*, and from which the United States—a unique nation, one without any certifiably wicked leaders throughout its entire history—is exempt. That this country, like every other country, has its tragic past does not sit well with the founding, and still all-powerful, belief in American exceptionalism. The national consensus on American history as a history of progress is a new setting for distressing photographs— one that focuses our attention on wrongs, both here and elsewhere, for which America sees itself as the solution or cure.

Even in the era of cybermodels, what the mind feels like is still, as the ancients imagined it, an inner space—like a theater— in which we picture, and it is these pictures that allow us to remember. The problem is not that people remember through photographs, but that they remember only the photographs. This remembering through photographs eclipses other forms of understanding, and remembering. The concen-

tration camps—that is, the photographs taken when the camps were liberated in 1945—are most of what people associate with Nazism and the miseries of the Second World War. Hideous deaths (by genocide, starvation, and epidemic) are most of what people retain of the whole clutch of iniquities and failures that have taken place in postcolonial Africa.

To remember is, more and more, not to recall a story but to be able to call up a picture. Even a writer as steeped in nineteenth-century and early modern literary solemnities as W. G. Sebald was moved to seed his lamentation-narratives of lost lives, lost nature, lost cityscapes with photographs. Sebald was not just an elegist, he was a militant elegist. Remembering, he wanted the reader to remember, too.

Harrowing photographs do not inevitably lose their power to shock. But they are not much help if the task is to understand. Narratives can make us understand. Photographs do something else: they haunt us. Consider one of the unforgettable images of the war in Bosnia, a photograph of which

the *New York Times* foreign correspondent John Kifner wrote: "The image is stark, one of the most enduring of the Balkan wars: a Serb militiaman casually kicking a dying Muslim woman in the head. It tells you everything you need to know." But of course it doesn't tell us everything we need to know.

From an identification given by the photographer, Ron Haviv, we learn the photograph was taken in the town of Bijeljina in April 1992, the first month of the Serb rampage through Bosnia. From behind, we see a uniformed Serb militiaman, a youthful figure with sunglasses perched on the top of his head, a cigarette between the second and third fingers of his raised left hand, rifle dangling in his right hand, right leg poised to kick a woman lying face down on the sidewalk between two other bodies. The photograph doesn't tell us that she is Muslim, though she is unlikely to have been labeled in any other way, for why would she and the two others be lying there, as if dead (why "dying"?), under the gaze of some Serb soldiers? In fact, the photograph tells us very little—except that war is hell, and that

graceful young men with guns are capable of kicking overweight older women lying helpless, or already killed, in the head.

The pictures of Bosnian atrocities were seen soon after the events took place. Like pictures from the Vietnam War, such as Ron Haberle's evidence of the massacre in March 1968 by a company of American soldiers of some five hundred unarmed civilians in the village of My Lai, they became important in bolstering the opposition to a war which was far from inevitable, far from intractable, and could have been stopped much sooner. Therefore one could feel an obligation to look at these pictures, gruesome as they were, because there was something to be done, right now, about what they depicted. Other issues are raised when we are invited to respond to a dossier of hitherto unknown pictures of horrors long past.

An example: a trove of photographs of black victims of lynching in small towns in the United States between the 1890s and the 1930s, which provided a shattering, revelatory experience for the thousands who saw them in a gallery in New York in 2000.

The lynching pictures tell us about human wickedness. About inhumanity. They force us to think about the extent of the evil unleashed specifically by racism. Intrinsic to the perpetration of this evil is the shamelessness of photographing it. The pictures were taken as souvenirs and made, some of them, into postcards; more than a few show grinning spectators, good churchgoing citizens as most of them had to be, posing for a camera with the backdrop of a naked, charred, mutilated body hanging from a tree. The display of these pictures makes us spectators, too.

What is the point of exhibiting these pictures? To awaken indignation? To make us feel "bad"; that is, to appall and sadden? To help us mourn? Is looking at such pictures really necessary, given that these horrors lie in a past remote enough to be beyond punishment? Are we the better for seeing these images? Do they actually teach us anything? Don't they rather just confirm what we already know (or want to know)?

All these questions were raised at the time of the exhibition and afterward when

[margin note: myth-busting? (p. 112)]

a book of the photographs, *Without Sanctuary*, was published. Some people, it was said, might dispute the need for this grisly photographic display, lest it cater to voyeuristic appetites and perpetuate images of black victimization—or simply numb the mind. Nevertheless, it was argued, there is an obligation to "examine"—the more clinical "examine" is substituted for "look at"— the pictures. It was further argued that submitting to the ordeal should help us understand such atrocities not as the acts of "barbarians" but as the reflection of a belief system, racism, that by defining one people as less human than another legitimates torture and murder. But maybe they *were* barbarians. Maybe *this* is what most barbarians look like. (They look like everybody else.)

That being said, one person's "barbarian" is another person's "just doing what everybody else is doing." (How many can be expected to do better than that?) The question is, Whom do we wish to blame? More precisely, Whom do we believe we have the right to blame? The children of Hiroshima and Nagasaki were no less

innocent than the young African-American men (and a few women) who were butchered and hanged from trees in small-town America. More than one hundred thousand civilians, three-fourths of them women, were massacred in the RAF firebombing of Dresden on the night of February 13, 1945; seventy-two thousand civilians were incinerated in seconds by the American bomb dropped on Hiroshima. The roll call could be much longer. Again, Whom do we wish to blame? Which atrocities from the incurable past do we think we are obliged to revisit?

Probably, if we are Americans, we think that it would be morbid to go out of our way to look at pictures of burnt victims of atomic bombing or the napalmed flesh of the civilian victims of the American war on Vietnam, but that we have a duty to look at the lynching pictures—if we belong to the party of the right-thinking, which on this issue is now very large. A stepped-up recognition of the monstrousness of the slave system that once existed, unquestioned by most, in the United States is a national project of recent

decades that many Euro-Americans feel some tug of obligation to join. This ongoing project is a great achievement, a benchmark of civic virtue. The acknowledgment of the American use of disproportionate firepower in war (in violation of one of the cardinal laws of war) is very much not a national project. A museum devoted to the history of America's wars that included the vicious war the United States fought against guerrillas in the Philippines from 1899 to 1902 (expertly excoriated by Mark Twain), and that fairly presented the arguments for and against using the atomic bomb in 1945 on the Japanese cities, with photographic evidence that showed what those weapons did, would be regarded—now more than ever—as a most unpatriotic endeavor.

6

ONE CAN FEEL OBLIGED to look at photographs that record great cruelties and crimes. One should feel obliged to think about what it means to look at them, about the capacity actually to assimilate what they show. Not all reactions to these pictures are under the supervision of reason and conscience. Most depictions of tormented, mutilated bodies do arouse a prurient interest. (*The Disasters of War* is notably an exception: Goya's images cannot be looked at in a spirit of prurience. They don't dwell on the beauty of the human body; bodies are heavy, and thickly clothed.) All images that display the violation of an attractive body are, to a certain degree, pornographic. But images of the repulsive can also allure. Everyone knows that what slows down highway traffic going past a horrendous car crash is not only curiosity. It is also, for

many, the wish to see something gruesome. Calling such wishes "morbid" suggests a rare aberration, but the attraction to such sights is not rare, and is a perennial source of inner torment.

Indeed, the very first acknowledgment (as far as I am aware) of the attraction of mutilated bodies occurs in a founding description of mental conflict. It is a passage in *The Republic*, Book IV, where Plato's Socrates describes how our reason may be overwhelmed by an unworthy desire, which drives the self to become angry with a part of its nature. Plato has been developing a tripartite theory of mental function, consisting of reason, anger or indignation, and appetite or desire—anticipating the Freudian schema of superego, ego, and id (with the difference that Plato puts reason on top and conscience, represented by indignation, in the middle). In the course of this argument, to illustrate how one may yield, even if reluctantly, to repulsive attractions, Socrates relates a story he heard about Leontius, son of Aglaion:

On his way up from the Piraeus out-
side the north wall, he noticed the
bodies of some criminals lying on the
ground, with the executioner stand-
ing by them. He wanted to go and
look at them, but at the same time he
was disgusted and tried to turn away.
He struggled for some time and cov-
ered his eyes, but at last the desire was
too much for him. Opening his eyes
wide, he ran up to the bodies and
cried, "There you are, curse you, feast
yourselves on this lovely sight."

Declining to choose the more common
example of an inappropriate or unlawful
sexual passion as his illustration of the
struggle between reason and desire, Plato
appears to take for granted that we also have
an appetite for sights of degradation and
pain and mutilation.

Surely the undertow of this despised im-
pulse must also be taken into account when
discussing the effect of atrocity pictures.

At the beginning of modernity, it may

have been easier to acknowledge that there exists an innate tropism toward the gruesome. Edmund Burke observed that people like to look at images of suffering. "I am convinced we have a degree of delight, and that no small one, in the real misfortunes and pains of others," he wrote in *A Philosophical Enquiry into the Origin of Our Ideas of the Sublime and Beautiful* (1757). "There is no spectacle we so eagerly pursue, as that of some uncommon and grievous calamity." William Hazlitt, in his essay on Shakespeare's Iago and the attraction of villainy on the stage, asks, "Why do we always read the accounts in the newspapers of dreadful fires and shocking murders?" Because, he answers, "love of mischief," love of cruelty, is as natural to human beings as is sympathy.

One of the great theorists of the erotic, Georges Bataille, kept a photograph taken in China in 1910 of a prisoner undergoing "the death of a hundred cuts" on his desk, where he could look at it every day. (Since become legendary, it is reproduced in the last of Bataille's books published during his lifetime, in 1961, *The Tears of Eros*.) "This

photograph," Bataille wrote, "had a decisive role in my life. I have never stopped being obsessed by this image of pain, at the same time ecstatic and intolerable." To contemplate this image, according to Bataille, is both a mortification of the feelings and a liberation of tabooed erotic knowledge—a complex response that many people must find hard to credit. For most, the image is simply unbearable: the already armless sacrificial victim of several busy knives, in the terminal stage of being flayed—a photograph, not a painting; a real Marsyas, not a mythic one—and still alive in the picture, with a look on his upturned face as ecstatic as that of any Italian Renaissance Saint Sebastian. As objects of contemplation, images of the atrocious can answer to several different needs. To steel oneself against weakness. To make oneself more numb. To acknowledge the existence of the incorrigible.

Bataille is not saying that he takes pleasure at the sight of this excruciation. But he is saying that he can imagine extreme suffering as something more than just suffering,

as a kind of transfiguration. It is a view of
suffering, of the pain of others, that is rooted
in religious thinking, which links pain to
sacrifice, sacrifice to exaltation—a view that
could not be more alien to a modern sensi-
bility, which regards suffering as something
that is a mistake or an accident or a crime.
Something to be fixed. Something to be
refused. Something that makes one feel
powerless.

What to do with such knowledge as photo-
graphs bring of faraway suffering? People
are often unable to take in the sufferings of
those close to them. (A compelling docu-
ment on this theme is Frederick Wiseman's
film *Hospital*.) For all the voyeuristic lure—
and the possible satisfaction of knowing,
This is not happening to me, I'm not ill, I'm
not dying, I'm not trapped in a war—it
seems normal for people to fend off think-
ing about the ordeals of others, even others
with whom it would be easy to identify.

A citizen of Sarajevo, a woman of im-

peccable adherence to the Yugoslav ideal, whom I met soon after arriving in the city the first time in April 1993, told me: "In October 1991 I was here in my nice apartment in peaceful Sarajevo when the Serbs invaded Croatia, and I remember when the evening news showed footage of the destruction of Vukovar, just a couple of hundred miles away, I thought to myself, 'Oh, how horrible,' and switched the channel. So how can I be indignant if someone in France or Italy or Germany sees the killing taking place here day after day on their evening news and says, 'Oh, how horrible,' and looks for another program. It's normal. It's human." Wherever people feel safe— this was her bitter, self-accusing point— they will be indifferent. But surely a Sarajevan might have another motive for shunning images of terrible events taking place in what was then, after all, another part of her own country than did those abroad who were turning their backs on Sarajevo. The dereliction of the foreigners, to whom she was so charitable, was also a consequence of the feeling that nothing could be

done. Her unwillingness to engage with these premonitory images of nearby war was an expression of helplessness and fear.

People can turn off not just because a steady diet of images of violence has made them indifferent but because they are afraid. As everyone has observed, there is a mounting level of acceptable violence and sadism in mass culture: films, television, comics, computer games. Imagery that would have had an audience cringing and recoiling in disgust forty years ago is watched without so much as a blink by every teenager in the multiplex. Indeed, mayhem is entertaining rather than shocking to many people in most modern cultures. But not all violence is watched with equal detachment. Some disasters are more apt subjects of irony than others.[9]

9. Tellingly, that connoisseur of death and high priest of the delights of apathy, Andy Warhol, was drawn to news reports of a variety of violent deaths (car and plane crashes, suicides, executions). But his silk-screened transcriptions excluded death in war. A news photo of an electric chair and a tabloid's screaming front page, "129 Die in Jet," yes. "Hanoi

It is because, say, the war in Bosnia didn't stop, because leaders claimed it was an intractable situation, that people abroad may have switched off the terrible images. It is because a war, any war, doesn't seem as if it can be stopped that people become less responsive to the horrors. Compassion is an unstable emotion. It needs to be translated into action, or it withers. The question is what to do with the feelings that have been aroused, the knowledge that has been communicated. If one feels that there is nothing "we" can do—but who is that "we"?—and nothing "they" can do either—and who are "they"?—then one starts to get bored, cynical, apathetic.

And it is not necessarily better to be moved. Sentimentality, notoriously, is entirely compatible with a taste for brutality

Bombed," no. The only photograph Warhol silkscreened that refers to the violence of war is one that had become iconic; that is, a cliché: the mushroom cloud of an atomic bomb, repeated as on a sheet of postage stamps (like the faces of Marilyn, Jackie, Mao) to illustrate its opaqueness, its fascination, its banality.

and worse. (Recall the canonical example of the Auschwitz commandant returning home in the evening, embracing his wife and children, and sitting at the piano to play some Schubert before dinner.) People don't become inured to what they are shown—if that's the right way to describe what happens—because of the *quantity* of images dumped on them. It is passivity that dulls feeling. The states described as apathy, moral or emotional anesthesia, are full of feelings; the feelings are rage and frustration. But if we consider what emotions would be desirable, it seems too simple to elect sympathy. The imaginary proximity to the suffering inflicted on others that is granted by images suggests a link between the faraway sufferers—seen close-up on the television screen—and the privileged viewer that is simply untrue, that is yet one more mystification of our real relations to power. So far as we feel sympathy, we feel we are not accomplices to what caused the suffering. Our sympathy proclaims our innocence as well as our impotence. To that extent, it can be (for all our good intentions)

an impertinent—if not an inappropriate—
response. To set aside the sympathy we ex-
tend to others beset by war and murderous
politics for a reflection on how our privi-
leges are located on the same map as their
suffering, and may—in ways we might pre-
fer not to imagine—be linked to their suf-
fering, as the wealth of some may imply the
destitution of others, is a task for which the
painful, stirring images supply only an ini-
tial spark.

7

CONSIDER TWO WIDESPREAD ideas—now fast approaching the stature of platitudes— on the impact of photography. Since I find these ideas formulated in my own essays on photography—the earliest of which was written thirty years ago—I feel an irresistible temptation to quarrel with them.

The first idea is that public attention is steered by the attentions of the media— which means, most decisively, images. When there are photographs, a war becomes "real." Thus, the protest against the Vietnam War was mobilized by images. The feeling that something had to be done about the war in Bosnia was built from the attentions of journalists—"the CNN effect," it was sometimes called—which brought images of Sarajevo under siege into hundreds of millions of living rooms night after night for more than three years. These examples illustrate the determining influence

of photographs in shaping what catastrophes and crises we pay attention to, what we care about, and ultimately what evaluations are attached to these conflicts.

The second idea—it might seem the converse of what's just been described—is that in a world saturated, no, hyper-saturated with images, those that should matter have a diminishing effect: we become callous. In the end, such images just make us a little less able to feel, to have our conscience pricked.

In the first of the six essays in *On Photography* (1977), I argued that while an event known through photographs certainly becomes more real than it would have been had one never seen the photographs, after repeated exposure it also becomes less real. As much as they create sympathy, I wrote, photographs shrivel sympathy. Is this true? I thought it was when I wrote it. I'm not so sure now. What is the evidence that photographs have a diminishing impact, that our culture of spectatorship neutralizes the moral force of photographs of atrocities?

The question turns on a view of the principal medium of the news, television. An image is drained of its force by the way it is used, where and how often it is seen. Images shown on television are by definition images of which, sooner or later, one tires. What looks like callousness has its origin in the instability of attention that television is organized to arouse and to satiate by its surfeit of images. Image-glut keeps attention light, mobile, relatively indifferent to content. Image-flow precludes a privileged image. The whole point of television is that one can switch channels, that it is normal to switch channels, to become restless, bored. Consumers droop. They need to be stimulated, jump-started, again and again. Content is no more than one of these stimulants. A more reflective engagement with content would require a certain intensity of awareness—just what is weakened by the expectations brought to images disseminated by the media, whose leaching out of content contributes most to the deadening of feeling.

The argument that modern life consists of a diet of horrors by which we are corrupted and to which we gradually become habituated is a founding idea of the critique of modernity—the critique being almost as old as modernity itself. In 1800, Wordsworth, in the Preface to *Lyrical Ballads*, denounced the corruption of sensibility produced by "the great national events which are daily taking place, and the increasing accumulation of men in cities, where the uniformity of their occupations produces a craving for extraordinary incident, which the rapid communication of intelligence hourly gratifies." This process of overstimulation acts "to blunt the discriminating powers of the mind" and "reduce it to a state of almost savage torpor."

The English poet had singled out the blunting of mind produced by "daily" events and "hourly" news of "extraordinary incident." (In 1800!) Exactly what kind of events and incidents was discreetly left to the reader's imagination. Some sixty years

later, another great poet and cultural diagnostician—French, and therefore as licensed to be hyperbolic as the English are prone to understate—offered a more heated version of the same charge. Here is Baudelaire writing in his journal in the early 1860s:

> It is impossible to glance through any newspaper, no matter what the day, the month or the year, without finding on every line the most frightful traces of human perversity . . . Every newspaper, from the first line to the last, is nothing but a tissue of horrors. Wars, crimes, thefts, lecheries, tortures, the evil deeds of princes, of nations, of private individuals; an orgy of universal atrocity. And it is with this loathsome appetizer that civilized man daily washes down his morning repast.

Newspapers did not yet carry photographs when Baudelaire wrote. But this doesn't make his accusatory description of the bourgeois sitting down with his morning

newspaper to breakfast with an array of the world's horrors any different from the contemporary critique of how much desensitizing horror we take in every day, via television as well as the morning paper. Newer technology provides a nonstop feed: as many images of disaster and atrocity as we can make time to look at.

Since *On Photography*, many critics have suggested that the excruciations of war—thanks to television—have devolved into a nightly banality. Flooded with images of the sort that once used to shock and arouse indignation, we are losing our capacity to react. Compassion, stretched to its limits, is going numb. So runs the familiar diagnosis. But what is really being asked for here? That images of carnage be cut back to, say, once a week? More generally, that we work toward what I called for in *On Photography*: an "ecology of images"? There isn't going to be an ecology of images. No Committee of Guardians is going to ration horror, to keep fresh its ability to shock. And the horrors themselves are not going to abate.

The view proposed in *On Photography*—
that our capacity to respond to our experi-
ences with emotional freshness and ethical
pertinence is being sapped by the relentless
diffusion of vulgar and appalling images—
might be called the conservative critique of
the diffusion of such images.

I call this argument conservative because
it is the sense of reality that is eroded.
There is still a reality that exists indepen-
dent of the attempts to weaken its author-
ity. The argument is in fact a defense of
reality and the imperiled standards for re-
sponding more fully to it.

In the more radical—cynical—spin on
this critique, there is nothing to defend: the
vast maw of modernity has chewed up
reality and spat the whole mess out as im-
ages. According to a highly influential
analysis, we live in a "society of spectacle."
Each situation has to be turned into a spec-
tacle to be real—that is, interesting—to
us. People themselves aspire to become

images: celebrities. Reality has abdicated. There are only representations: media.

Fancy rhetoric, this. And very persuasive to many, because one of the characteristics of modernity is that people like to feel they can anticipate their own experience. (This view is associated in particular with the writings of the late Guy Debord, who thought he was describing an illusion, a hoax, and of Jean Baudrillard, who claims to believe that images, simulated realities, are all that exist now; it seems to be something of a French specialty.) It is common to say that war, like everything else that appears to be real, is *médiatique*. This was the diagnosis of several distinguished French day-trippers to Sarajevo during the siege, among them André Glucksmann: that the war would be won or lost not by anything that happened in Sarajevo, or indeed in Bosnia, but by what happened in the media. It is often asserted that "the West" has increasingly come to see war itself as a spectacle. Reports of the death of reality—like the death of reason, the death of the intellectual, the death of serious literature—

seem to have been accepted without much reflection by many who are attempting to understand what feels wrong, or empty, or idiotically triumphant in contemporary politics and culture.

To speak of reality becoming a spectacle is a breathtaking provincialism. It universalizes the viewing habits of a small, educated population living in the rich part of the world, where news has been converted into entertainment—that mature style of viewing which is a prime acquisition of "the modern," and a prerequisite for dismantling traditional forms of party-based politics that offer real disagreement and debate. It assumes that everyone is a spectator. It suggests, perversely, unseriously, that there is no real suffering in the world. But it is absurd to identify the world with those zones in the well-off countries where people have the dubious privilege of being spectators, or of declining to be spectators, of other people's pain, just as it is absurd to generalize about the ability to respond to the sufferings of others on the basis of the mind-set of those consumers of news who know

nothing at first hand about war and massive injustice and terror. There are hundreds of millions of television watchers who are far from inured to what they see on television. They do not have the luxury of patronizing reality.

It has become a cliché of the cosmopolitan discussion of images of atrocity to assume that they have little effect, and that there is something innately cynical about their diffusion. As important as people now believe images of war to be, this does not dispel the suspicion that lingers about the interest in these images, and the intentions of those who produce them. Such a reaction comes from two extremes of the spectrum: from cynics who have never been near a war, and from the war-weary who are enduring the miseries being photographed.

Citizens of modernity, consumers of violence as spectacle, adepts of proximity without risk, are schooled to be cynical about the possibility of sincerity. Some people will do anything to keep themselves from being moved. How much easier, from one's chair, far from danger, to claim the po-

sition of superiority. In fact, deriding the efforts of those who have borne witness in war zones as "war tourism" is such a recurrent judgment that it has spilled over into the discussion of war photography as a profession.

The feeling persists that the appetite for such images is a vulgar or low appetite; that it is commercial ghoulishness. In Sarajevo in the years of the siege, it was not uncommon to hear, in the middle of a bombardment or a burst of sniper fire, a Sarajevan yelling at the photojournalists, who were easily recognizable by the equipment hanging round their necks, "Are you waiting for a shell to go off so you can photograph some corpses?"

Sometimes they were, though less often than one might imagine, since the photographer on the street in the middle of a bombardment or a burst of sniper fire ran just as much risk of being killed as the civilians he or she was tracking. Further, pursuing a good story was not the only motive for the avidity and the courage of the photojournalists covering the siege. For the duration of this conflict, most of the many experienced

journalists who reported from Sarajevo were not neutral. And the Sarajevans did want their plight to be recorded in photographs: victims are interested in the representation of their own sufferings. But they want the suffering to be seen as unique. In early 1994, the English photojournalist Paul Lowe, who had been living for more than a year in the besieged city, mounted an exhibit at a partly wrecked art gallery of the photographs he had been taking, along with photographs he'd taken a few years earlier in Somalia; the Sarajevans, though eager to see new pictures of the ongoing destruction of their city, were offended by the inclusion of the Somalia pictures. Lowe had thought the matter was a simple one. He was a professional photographer, and these were two bodies of work of which he was proud. For the Sarajevans, it was also simple. To set their sufferings alongside the sufferings of another people was to compare them (which hell was worse?), demoting Sarajevo's martyrdom to a mere instance. The atrocities taking place in Sarajevo have nothing to do with what happens in Africa, they ex-

claimed. Undoubtedly there was a racist tinge to their indignation—Bosnians are Europeans, people in Sarajevo never tired of pointing out to their foreign friends—but they would have objected too if, instead, pictures of atrocities committed against civilians in Chechnya or in Kosovo, indeed in any other country, had been included in the show. It is intolerable to have one's own sufferings twinned with anybody else's.

8

TO DESIGNATE A HELL IS NOT, of course, to tell us anything about how to extract people from that hell, how to moderate hell's flames. Still, it seems a good in itself to acknowledge, to have enlarged, one's sense of how much suffering caused by human wickedness there is in the world we share with others. Someone who is perennially surprised that depravity exists, who continues B/D to feel disillusioned (even incredulous) when confronted with evidence of what humans are capable of inflicting in the way of gruesome, hands-on cruelties upon other humans, has not reached moral or psychological adulthood.

No one after a certain age has the right to this kind of innocence, of superficiality, to this degree of ignorance, or amnesia. or sleep

There now exists a vast repository of images that make it harder to maintain this kind of moral defectiveness. Let the

atrocious images haunt us. Even if they are only tokens, and cannot possibly encompass most of the reality to which they refer, they still perform a vital function. The images say: This is what human beings are capable of doing—may volunteer to do, enthusiastically, self-righteously. Don't forget.

This is not quite the same as asking people to remember a particularly monstrous bout of evil. ("Never forget.") Perhaps too much value is assigned to memory, not enough to thinking. Remembering *is* an ethical act, has ethical value in and of itself. Memory is, achingly, the only relation we can have with the dead. So the belief that remembering is an ethical act is deep in our natures as humans, who know we are going to die, and who mourn those who in the normal course of things die before us— grandparents, parents, teachers, and older friends. Heartlessness and amnesia seem to go together. But history gives contradictory signals about the value of remembering in the much longer span of a collective history. There is simply too much injustice in the world. And too much remembering (of an-

cient grievances: Serbs, Irish) embitters. To make peace is to forget. To reconcile, it is necessary that memory be faulty and limited.

b/c (mind?)

If the goal is having some space in which to live one's own life, then it is desirable that the account of specific injustices dissolve into a more general understanding that human beings everywhere do terrible things to one another.

to avoid letting personal history bitterness makes us naive to others suffering

Parked in front of the little screens— television, computer, palmtop—we can surf to images and brief reports of disasters throughout the world. It seems as if there is a greater quantity of such news than before. This is probably an illusion. It's just that the spread of news is "everywhere." And some people's sufferings have a lot more intrinsic interest to an audience (given that suffering must be acknowledged as having an audience) than the sufferings of others. That news about war is now disseminated worldwide does not mean that the capacity to think about the suffering of people far

away is significantly larger. In a modern life—a life in which there is a superfluity of things to which we are invited to pay attention—it seems normal to turn away from images that simply make us feel bad. Many more would be switching channels if the news media were to devote more time to the particulars of human suffering caused by war and other infamies. But it is probably not true that people are responding less.

That we are not totally transformed, that we can turn away, turn the page, switch the channel, does not impugn the ethical value of an assault by images. It is not a defect that we are not seared, that we do not suffer *enough*, when we see these images. Neither is the photograph supposed to repair our ignorance about the history and causes of the suffering it picks out and frames. Such images cannot be more than an invitation to pay attention, to reflect, to learn, to examine the rationalizations for mass suffering offered by established powers. Who caused what the picture shows? Who is responsible? Is it excusable? Was it inevitable? Is

there some state of affairs which we have ac-
cepted up to now that ought to be chal-
lenged? All this, with the understanding
that moral indignation, like compassion,
cannot dictate a course of action.

The frustration of not being able to do
anything about what the images show may
be translated into an accusation of the in-
decency of regarding such images, or the
indecencies of the way such images are
disseminated—flanked, as they may well
be, by advertising for emollients, pain reliev-
ers, and SUVs. If we could do something
about what the images show, we might not
care as much about these issues.

Images have been reproached for being a
way of watching suffering at a distance, as
if there were some other way of watching.
But watching up close—without the medi-
ation of an image—is still just watching.

Some of the reproaches made against
images of atrocity are not different from
characterizations of sight itself. Sight is

effortless; sight requires spatial distance; sight can be turned off (we have lids on our eyes, we do not have doors on our ears). The very qualities that made the ancient Greek philosophers consider sight the most excellent, the noblest of the senses are now associated with a deficit.

It is felt that there is something morally wrong with the abstract of reality offered by photography; that one has no right to experience the suffering of others at a distance, denuded of its raw power; that we pay too high a human (or moral) price for those hitherto admired qualities of vision—the standing back from the aggressiveness of the world which frees us for observation and for elective attention. But this is only to describe the function of the mind itself.

There's nothing wrong with standing back and thinking. To paraphrase several sages: "Nobody can think and hit someone at the same time."

9

CERTAIN PHOTOGRAPHS—emblems of suffering, such as the snapshot of the little boy in the Warsaw Ghetto in 1943, his hands raised, being herded to the transport to a death camp—can be used like memento mori, as objects of contemplation to deepen one's sense of reality; as secular icons, if you will. But that would seem to demand the equivalent of a sacred or meditative space in which to look at them. Space reserved for being serious is hard to come by in a modern society, whose chief model of a public space is the mega-store (which may also be an airport or a museum).

It seems exploitative to look at harrowing photographs of other people's pain in an art gallery. Even those ultimate images whose gravity, whose emotional power, seems fixed for all time, the concentration camp photographs from 1945, weigh differently when seen in a photography museum

(the Hôtel Sully in Paris, the International
Center of Photography in New York); in a
gallery of contemporary art; in a museum
catalogue; on television; in the pages of *The
New York Times*; in the pages of *Rolling
Stone*; in a book. A photograph seen in a
photo album or printed on rough newsprint
(like the Spanish Civil War photographs)
means something different when displayed
in an Agnès B. boutique. Every picture is
seen in some setting. And the settings have
multiplied. A notorious advertising cam-
paign for Benetton, the Italian manufac-
turer of casual clothing, used a photograph
of the blood-stained shirt of a dead Croa-
tian soldier. Advertising photographs are
often just as ambitious, artful, slyly casual,
transgressive, ironic, and solemn as art
photography. When Capa's falling soldier
appeared in *Life* opposite the Vitalis ad,
there was a huge, unbridgeable difference
in look between the two kinds of photo-
graphs, "editorial" and "advertising." Now
there is not.

Much of the current skepticism about
the work of certain photographers of con-

science seems to amount to little more than displeasure at the fact that photographs are circulated so diversely; that there is no way to guarantee reverential conditions in which to look at these pictures and be fully responsive to them. Indeed, apart from the settings where patriotic deference to leaders is exercised, there seems no way to guarantee contemplative or inhibiting space for anything now.

So far as photographs with the most solemn or heartrending subject matter are art—and this is what they become when they hang on walls, whatever the disclaimers—they partake of the fate of all wall-hung or floor-supported art displayed in public spaces. That is, they are stations along a—usually accompanied—stroll. A museum or gallery visit is a social situation, riddled with distractions, in the course of which art is seen and commented on.[10] Up to a point, the weight and seri-

10. The evolution of the museum itself has gone far toward expanding this ambience of distraction. Once a repository for conserving and displaying the

ousness of such photographs survive better in a book, where one can look privately, linger over the pictures, without talking. Still, at some moment the book will be closed. The strong emotion will become a transient one. Eventually the specificity of the photographs' accusations will fade; the denunciation of a particular conflict and

fine arts of the past, the museum has become a vast educational institution-cum-emporium, one of whose functions is the exhibition of art. The primary function is entertainment and education in various mixes, and the marketing of experiences, tastes, and simulacra. The Metropolitan Museum of Art in New York mounts an exhibition of the clothes worn by Jacqueline Bouvier Kennedy Onassis during her White House years, and the Imperial War Museum in London, admired for its collections of military hardware and pictures, now offers two replicated environments to visitors: from the First World War, *The Trench Experience* (the Somme in 1916), a walk-through complete with taped sounds (exploding shells, cries) but odorless (no rotting corpses, no poison gas); and from the Second World War, *The Blitz Experience*, described as a presentation of conditions during the German bombing of London in 1940, including the simulation of an air raid as experienced in an underground shelter.

attribution of specific crimes will become a denunciation of human cruelty, human savagery as such. The photographer's intentions are irrelevant to this larger process.

Is there an antidote to the perennial seductiveness of war? And is this a question a woman is more likely to pose than a man? (Probably yes.)

Could one be mobilized actively to oppose war by an image (or a group of images) as one might be enrolled among the opponents of capital punishment by reading, say, Dreiser's *An American Tragedy* or Turgenev's "The Execution of Troppmann," an account by the expatriate writer, invited to be an observer in a Paris prison, of a famous criminal's last hours before being guillotined? A narrative seems likely to be more effective than an image. Partly it is a question of the length of time one is obliged to look, to feel. No photograph or portfolio of photographs can unfold, go further, and further still, as do *The Ascent*

(1977), by the Ukrainian director Larisa Shepitko, the most affecting film about the sadness of war I know, and an astounding Japanese documentary, Kazuo Hara's *The Emperor's Naked Army Marches On* (1987), the portrait of a "deranged" veteran of the Pacific war, whose life's work is denouncing Japanese war crimes from a sound truck he drives through the streets of Tokyo and paying most unwelcome visits to his former superior officers, demanding that they apologize for crimes, such as the murder of American prisoners in the Philippines, which they either ordered or condoned.

Among single antiwar images, the huge photograph that Jeff Wall made in 1992 titled "Dead Troops Talk (A Vision After an Ambush of a Red Army Patrol near Moqor, Afghanistan, Winter 1986)" seems to me exemplary in its thoughtfulness and power. The antithesis of a document, the picture, a Cibachrome transparency seven and a half feet high and more than thirteen feet wide and mounted on a light box, shows figures posed in a landscape, a blasted hillside, that was constructed in the artist's studio. Wall,

who is Canadian, was never in Afghanistan.
The ambush is a made-up event in a savage
war that had been much in the news. Wall
set as his task the imagining of war's horror
(he cites Goya as an inspiration), as in
nineteenth-century history painting and
other forms of history-as-spectacle that
emerged in the late eighteenth and early
nineteenth centuries—just before the in-
vention of the camera—such as tableaux
vivants, wax displays, dioramas, and pa-
noramas, which made the past, especially
the immediate past, seem astonishingly, dis-
turbingly real.

The figures in Wall's visionary photo-
work are "realistic" but, of course, the im-
age is not. Dead soldiers don't talk. Here
they do.

Thirteen Russian soldiers in bulky win-
ter uniforms and high boots are scattered
about a pocked, blood-splashed slope lined
with loose rocks and the litter of war: shell
casings, crumpled metal, a boot that holds
the lower part of a leg . . . The scene might
be a revised version of the end of Gance's
J'accuse, when the dead soldiers from the

First World War rise from their graves, but these Russian conscripts, slaughtered in the Soviet Union's own late folly of a colonial war, were never buried. A few still have their helmets on. The head of one kneeling figure, talking animatedly, foams with his red brain matter. The atmosphere is warm, convivial, fraternal. Some slouch, leaning on an elbow, or sit, chatting, their opened skulls and destroyed hands on view. One man bends over another who lies on his side as if asleep, perhaps encouraging him to sit up. Three men are horsing around: one with a huge wound in his belly straddles another, lying prone, who is laughing at a third man, on his knees, who playfully dangles before him a strip of flesh. One soldier, helmeted, legless, has turned to a comrade some distance away, an alert smile on his face. Below him are two who don't seem quite up to the resurrection and lie supine, their bloodied heads hanging down the stony incline.

Engulfed by the image, which is so accusatory, one could fantasize that the soldiers might turn and talk to us. But no, no one is looking out of the picture. There's no threat

of protest. They are not about to yell at us to bring a halt to that abomination which is war. They haven't come back to life in order to stagger off to denounce the war-makers who sent them to kill and be killed. And they are not represented as terrifying to others, for among them (far left) sits a white-garbed Afghan scavenger, entirely absorbed in going through somebody's kit bag, of whom they take no note, and entering the picture above them (top right) on the path winding down the slope are two Afghans, perhaps soldiers themselves, who, it would seem from the Kalashnikovs collected near their feet, have already stripped the dead soldiers of their weapons. These dead are supremely uninterested in the living: in those who took their lives; in witnesses—and in us. Why should they seek our gaze? What would they have to say to us? "We"—this "we" is everyone who has never experienced anything like what they went through—don't understand. We don't get it. We truly can't imagine what it was like. We can't imagine how dreadful, how terrifying war is; and how normal it becomes.

Can't understand, can't imagine. That's what every soldier, and every journalist and aid worker and independent observer who has put in time under fire, and had the luck to elude the death that struck down others nearby, stubbornly feels. And they are right.

ACKNOWLEDGMENTS

A part of the argument of this book, in its earliest form, was delivered as an Amnesty Lecture at Oxford University in February 2001 and subsequently published in a collection of Amnesty Lectures titled *Human Rights, Human Wrongs* (Oxford University Press, 2003); I thank Nick Owen of New College for the invitation to give the lecture and for his hospitality. A sliver of the argument appeared as the preface to *Don McCullin*, a compendium of photographs by McCullin published in 2002 by Jonathan Cape. I am grateful to Mark Holborn, who edits photography books at Cape in London, for encouragement; to my first reader, Paolo Dilonardo, as always; to Robert Walsh for his discernment, again; and, for theirs, to Minda Rae Amiran, Peter Perrone, Benedict Yeoman, and Oliver Schwaner-Albright.

I was stimulated and moved by an article

by Cornelia Brink, "Secular Icons: Looking at Photographs from Nazi Concentration Camps," in *History & Memory* vol. 12, no. 1 (Spring/Summer 2000), and by Barbie Zelizer's excellent *Remembering to Forget: Holocaust Memory Through the Camera's Eye* (University of Chicago Press, 1998), where I found the Lippmann quote. For information about the Royal Air Force's punitive bombing war on Iraqi villages between 1920 and 1924, an article in *Aerospace Power Journal* (Winter 2000), by James S. Corum, who teaches at the School of Advanced Airpower Studies at Maxwell Air Force Base, Alabama, provides valuable information and analysis. Accounts of the restrictions placed on photojournalists during the Falklands War and the Gulf War are given in two important books: *Body Horror: Photojournalism, Catastrophe, and War*, by John Taylor (Manchester University Press, 1998), and *War and Photography*, by Caroline Brothers (Routledge, 1997). Brothers sums up the case against the authenticity of the Capa photograph on pp. 178–84 of her book. For an oppos-

ing view: Richard Whelan's article "Robert Capa's Falling Soldier," in *Aperture* no. 166 (Spring 2002), adduces a set of morally ambiguous circumstances at the front in the course of which, he argues, Capa did inadvertently photograph a Republican soldier being killed.

For information about Roger Fenton, I am indebted to Natalie M. Houston, "Reading the Victorian Souvenir: Sonnets and Photographs of the Crimean War," *The Yale Journal of Criticism* vol. 14, no. 2 (Fall 2001). I owe the information that there were two versions of Fenton's "The Valley of the Shadow of Death" to Mark Haworth-Booth of the Victoria and Albert Museum; both are reproduced in *The Ultimate Spectacle: A Visual History of the Crimean War*, by Ulrich Keller (Routledge, 2001). The account of the British reaction to the photograph of unburied British dead at the Battle of Spion Kop comes from *Early War Photographs*, compiled by Pat Hodgson (New York Graphic Society, 1974). It was William Frassanito who established, in his *Gettysburg: A Journey*

in Time (Scribner's, 1975), that Alexander Gardner must have changed the location of the body of a dead Confederate soldier for a photograph. The quote from Gustave Moynier comes from David Rieff, *A Bed for the Night: Humanitarianism in Crisis* (Simon & Schuster, 2002).

I continue to learn, as I have for many years, from conversations with Ivan Nagel.

12/1/18
(D.C.) alterity of spaces correlative to their sexiness?
(Foucault & Perel) eros kindled by play, adventure, danger
(& otherness more generally)
commerce, trade-routes &
the desirable (other/object) fictional accounts (imagos,
texts are also erotic lit)
"other spaces"
heterotopias Desire hinges on an
awareness of alterity,
intimacy on familiarity.

Is all sex with dolls a sublimated necrophilia?
"tabula rasa" responsiveness or unresponsive?"
extension (so it were) of a dildo (conceptually/functionally)
an aid to fantasy & physical stimulus in its own right

Next up: The Present Age, Kierkegaard